BULLDOGS
ON ICE
YALE UNIVERSITY MEN'S ICE HOCKEY

D1214847

BULLDOGS ON ICE

YALE UNIVERSITY MEN'S ICE HOCKEY

Daniel K. Fleschner

ARCADIA

First printed in 2003.

Published by Arcadia Publishing,
an imprint of Tempus Publishing Inc.
2A Cumberland Street
Charleston, SC 29401

Printed in Great Britain.

Library of Congress Catalog Card Number: 2003107823

For all general information, contact Arcadia Publishing:
Telephone 843-853-2070
Fax 843-853-0044
E-mail sales@arcadiapublishing.com

For customer service and orders:
Toll-free 1-888-313-2665

Visit us on the Internet at www.arcadiapublishing.com.

CONTENTS

ACKNOWLEDGMENTS

Unless otherwise noted, all images are courtesy of the Yale University Athletic Department. Thanks to the members of the athletic department for granting me access to the archives.

This book would not have been possible without the recollections, musings, clippings, and photographs provided to me by former Yale hockey players (and one wife), including John Akers, Barry Allardice, Peter Allen, Dave Baseggio, Doug Billman, Dean Boylan, Mike Brooks, Allen Clapp, John Cole, Billy Conway, David Crosby, Pete Cruikshank, Jack Duffy, Luke Earl, John Emmons, Franklin Farrel, Ace Frank, Jeff Glew, Dewitt Godfrey, Tom Goodale, Mike Hanson, Archer Harman Jr., Dave Harrington, Harry Havemeyer, Steve Holahan, Toby Hubbard, Daryl Jones, Zoran Kozic, Gary Lawrence, Paul Lawson, Martin Leroux, Bob Logan, Prescott Logan, Jim Macdonald, Ken MacKenzie, Ken MacLean, Francois Magnant, Bill Matthews, Scott Matusovich, Keith McCullough, Ed McGonagle, Tom McNamara, Dwight Miller, Jim Murphy, Rob Mutter, Larry Noble Jr., Bobby Noyes, John Ormiston, Fred Pearson, Nancy Pike, Dan Poliziani, Leigh Quinn, Spencer Rodgers, D'Arcy Ryan, George Scherer, George Semler, Ted Shay, Bruce Smith, Adam Snow, Ben Stafford, Richard Starratt, Todd Sullivan, Paul Tortorella, Jack Walsh, Andy Weidenbach, Blair Wheeler, Bruce Wolanin, Bill Wood, Randy Wood, and Michael Yoshino.

I am indebted to Steve Conn, Mike Corwin, John Hyman, and Sam Rubin for their editorial assistance. I would also like to thank Peter Diamond and Joe Gesue at NBC for allowing me to work on this project.

Statistics that were not provided by the Yale University Athletic Department were gathered through hockeydb.com.

I, of course, could not have done this book without my parents, for a variety of reasons. Specifically, they housed, fed, clothed, and transported me on my trips up to New Haven from New York City, leaving me to concentrate solely on getting my work done.

INTRODUCTION

In January 1896, when a group of Yale students traveled to Baltimore bearing skates and sticks, few observers could have known the importance of what those students were about to do. During the previous year and a half, two Yale athletes—Malcolm Chace and Arthur Foote—had gone to Canada and upstate New York for tennis tournaments. While on those trips, the two Elis had been exposed to a game the Canadians were perfecting, but which had not yet made its way to American colleges: ice hockey.

Smitten with the sport, Chace and Foote set about forming a hockey team at Yale and arranged for its first official games to be played in Baltimore in 1896. After facing off with the Baltimore Athletic Club on January 31 (a 3-2 loss), the Yale players made history. They took on Johns Hopkins on February 1 in the first intercollegiate ice hockey game in American history (a 2-2 tie).

Since that historic event, the growth of collegiate ice hockey has been astronomical. Today, there are 214 men's and women's varsity teams, including 60 men's programs playing at the NCAA Division I level. Yale was there at the start, in 1896, and unlike Johns Hopkins, it is still there today.

In the early years of college hockey, Yale was one of the nation's elite teams, winning intercollegiate titles in 1899, 1900, and 1902. Until 1911, the team played its home games on outdoor rinks in the New Haven area, including one at Lake Whitney on the New Haven-Hamden town line. In 1911, the school opened an indoor structure at Yale Field. The venue, which was made of wood on a steel frame, had the largest ice surface in the country at that time (190 feet by 90 feet). The Elis beat M.I.T. on January 13, 1911, to open the arena, but it was soon closed because of problems with the ground underneath the structure.

From 1914 until 1917, the team played its home games at the old New Haven Arena at the corner of State and Wall Streets. Between 1917 and 1921, the arena was declared unplayable and was shut down. Venue problems and World War I forced the team to contest a reduced schedule, and its home games for two years were played in Philadelphia.

Frederick Rocque served as Yale's first hockey coach from 1916 to 1917, but no other coach stayed for more than one year until Clarence Wanamaker took over the program in 1921. That year, the Elis returned to the New Haven Arena and remained there until it burned down in 1924.

Wanamaker led the Elis for seven years, including an 18-4-1 season in 1923–24 and a 14-1-1 campaign the following year. After 1924, the team played on various outdoor rinks in the

New Haven area until moving into the "new" New Haven Arena in January 1927.

Larry Noble, the team's captain in 1926–27, succeeded Wanamaker as coach in 1928. Under Noble for two years, Yale's record was an incredible 32-2-2, and including its first year under former Yale goaltender Holcomb York, the Elis' record was 47-3-3 in a three-year span. York was coach from 1930 until 1938, an era during which five future Olympians played at Yale.

Yale joined the Quadrangular League in 1934, along with Dartmouth, Harvard, and Princeton (now known as the Ivy Hockey League). The Elis won the first league title in 1934–35, compiling a 6-1 record against their three conference foes.

One of the two names synonymous with Yale hockey took over the program as head coach in 1938. Murray Murdoch, the first player ever signed by the NHL's New York Rangers, took the reins of the program and held them for 27 seasons. During his tenure, Yale compiled a record of 278-236-20, won a Quadrangular League title in 1940, a Pentagonal League crown in 1952 (Army was added to the conference in 1941 and the league's name was changed as a result), and played in the NCAA tournament in 1952 as well. The team moved into its current home, Ingalls Rink (known colloquially as the "Yale Whale"), in 1959, and the program joined the newly formed Eastern College Athletic Conference (ECAC) in 1961.

Some of the finest skaters in Yale history played for Murdoch, including great scorers like Ted Shay, Wally Kilrea, and Jack Morrison (a 1968 Olympian) and outstanding goaltenders Gerry Jones (Yale's first All-American, in 1959) and George Scherer.

Beginning in the last years of Murdoch's time as head coach and stretching through the tenures of his successors Dick Gagliardi and Paul Lufkin, the program mostly struggled until 1963 Harvard captain Tim Taylor signed on as head coach in 1976.

Taylor had an immediate impact; in the first game he coached, Yale defeated Pennsylvania for the school's first official Ivy League win in more than two years. Taylor has gone on to lead the Elis to an ECAC title along with six Ivy crowns and a trip to the NCAA tournament in 1998. He has surpassed Murdoch for the most wins in school history and has raised the visibility of the program immeasurably since inheriting a team that had only five wins in its previous two seasons combined.

Five Hobey Baker Memorial Award finalists have played for Taylor: Bob Brooke, Mark Kaufmann, Ray Giroux, Jeff Hamilton (a two-time finalist), and Chris Higgins. The Eli mentor also coached the 1994 U.S. Olympic team.

Today, Yale men's ice hockey is a New England institution. For the past several years, the team has consistently drawn sell-out crowds to Ingalls Rink. The fans are a mix of male and female, young and old, town and gown, all united in their support of the Elis.

Much has changed in college hockey, on the Yale campus, and throughout the world since Malcolm Chace led the first Eli skaters to Baltimore in 1896. But some things have stayed the same, particularly Yale's vital role in the history of college hockey and the sense of pride that every player, coach, and fan feels when the Bulldogs take the ice.

One
THE BIRTH OF COLLEGE HOCKEY AND BEYOND (1896–1938)

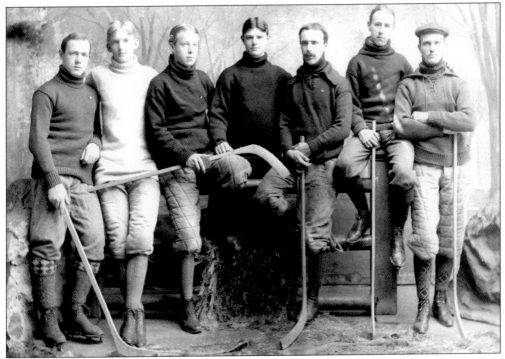

THE 1896 TEAM. Yale's first official game was against the Baltimore Athletic Club on January 31, 1896, and resulted in a 3-2 loss. The following day, Yale played Johns Hopkins in the first intercollegiate hockey game in U.S. history (a 2-2 tie). Thirteen days later, Yale picked up its first-ever win, 2-1, over Johns Hopkins, and the Elis finished their season by beating the Baltimore Athletic Club, 3-1. So began the history of Yale hockey, with a 2-1-1 record under the leadership of Malcolm Chace, the captain.

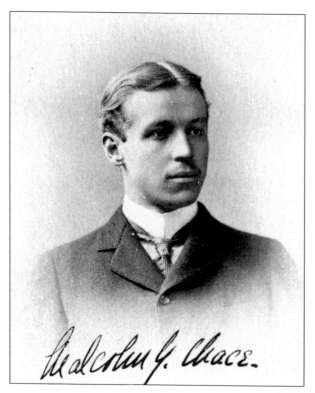

Malcolm G. Chace.

Malcolm Chace '96. One of the two men considered the fathers of Yale hockey, Malcolm Chace, "the blond-haired wonder," was a tennis star who initially went to Brown. In Providence, he won two intercollegiate national tennis championships before transferring to Yale in 1894. At Yale, he won four more tennis titles, including a pair of doubles crowns with Arthur Foote. But his main contribution to college sport was bringing hockey to Yale. He was the captain of the first Eli hockey team, in 1896.

Arthur Foote '96. As a member of the Eli tennis team, New Haven native Arthur Foote joined with classmate Malcolm Chace to win two intercollegiate national tennis championships (in doubles). On trips to northern New York and Canada for tennis tournaments, Foote and Chace were introduced to hockey, which they brought back to Yale. Foote was a member of the first Yale hockey team, in 1896, which played the first intercollegiate game in American history.

10

HENRY STODDARD '02. The captain of Yale's last intercollegiate championship team in 1901–02, Henry Stoddard scored 27 goals that year, a mark that has been surpassed only once, by Ding Palmer (52 goals) in 1927–28. Stoddard prepped for Yale at St. Paul's and Taft and went on to Harvard Law School (after his Yale team beat the Crimson three times in his senior year). After his law career, Stoddard became a hog farmer.

ARCHER HARMAN SR. '13. Archer Harman Sr. is a member of two exclusive clubs in Yale hockey history. As captain of the 1911–12 and 1912–13 teams, he is one of only four men to act as captain of the Elis twice. In addition, he and his son, Archer Harman Jr., are one of three father-son duos to captain the Yale hockey team (his son was captain in 1944–45). Harman was a good friend of Hobey Baker (a schoolmate at St. Paul's), and the Princeton great and college hockey legend was an usher at his wedding.

DAVID S. INGALLS '20. David S. Ingalls Sr. is one of the more famed Yale hockey players for several reasons. Yale's home arena, David S. Ingalls Rink, bears his name, as well as that of his son, who captained the 1955–56 Elis. Ingalls Sr. also is the last player to captain two teams of Yale skaters—the 1918–19 team that played only two games because of World War I and the 1919–20 team. He had four goals to lead the team in 1918–19 and again paced the squad with 15 goals the following year. Ingalls was the first U.S. Navy pilot to achieve ace status, flying a Sopwith Camel in World War I. He went on to be assistant secretary of the Navy for aviation (1929) and served in World War II, eventually retiring from the service as a rear admiral.

CLARENCE WANAMAKER. The third official coach of the Elis, Clarence Wanamaker served as Yale mentor for seven seasons, from 1921 until 1928. Under his direction, the Elis posted a 76-41-4 record, including two of the most successful teams in school history: the 1923–24 squad that was 18-4-1 and the 1924–25 team that was 14-1-1. Prior to his time at Yale, Wanamaker coached at Dartmouth, his alma mater, from 1915 until 1920.

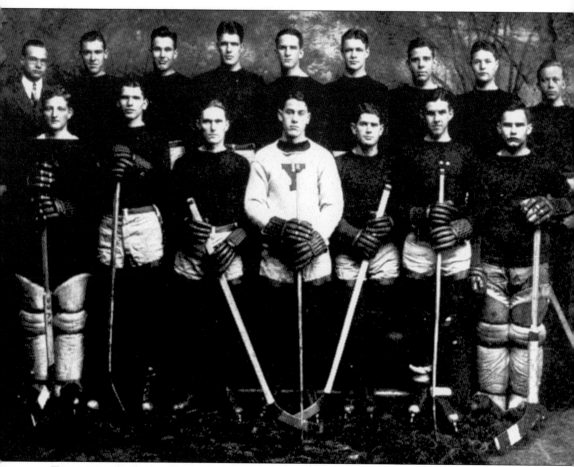

THE 1923–24 TEAM. One of the great teams in early Yale history, the 1923–24 squad posted an 18-4-1 record under coach Clarence Wanamaker and captain Charles O'Hearn. The 18 wins set a school record that stood for more than six decades, until the 1985–86 Elis notched 20 victories. In 1923–24, Yale lost just one game to a collegiate opponent (a 1-0 loss at Princeton), while its other three defeats came to the New Haven Bears (twice) and the Cleveland Athletic Club. The team allowed only 30 goals that year (a current school record) thanks to the outstanding play of goaltender Al Jenkins, one of the best netminders in Yale history.

CHARLIE O'HEARN '24s. An outstanding all-around athlete, Charlie O'Hearn was the captain of the Yale hockey and baseball teams and a three-year letterwinner on the gridiron. As a junior, he led the Elis with 14 goals and captained the team to an 18-4-1 record in his senior campaign. On the football field, he drop-kicked a 52-yard field goal against Carnegie Tech in 1922; this play is tied for the second-longest successful kick in Yale history.

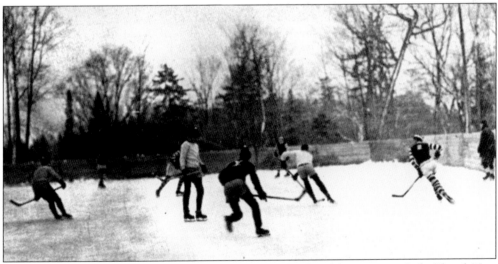

LAKE PLACID, 1923–24. In the winter of 1923–24, Yale played four games in Lake Placid, New York, the future host city of the 1932 and 1980 Olympic Winter Games and the ECAC finals from 1993 to 2002. On their trip in that season, the Elis won all four of their games, defeating Dartmouth, Williams, Amherst, and Dartmouth a second time. In this photograph, the team is practicing on an outdoor rink.

Lawrence Noble '27. Lawrence Noble was a very successful athlete and coach at Yale. He starred for the Eli hockey, baseball, and football teams and was captain of the skaters in 1926–27 (as was his son in 1952–53). After graduating in 1927, he enrolled at Yale Law School, paying his way through school as a coach. In his first year, he coached the junior varsity football and freshman hockey teams. For the following two remarkable years, he was head coach of the varsity hockey team as the Elis posted a record of 32-2-2. He briefly practiced law in New York before joining the faculty of the Groton School, where he taught Latin and history and coached football, hockey, and baseball. He served as director of admissions for 10 years before retiring.

DICK VAUGHAN '28. Dick Vaughan captained both the 1927–28 Yale hockey team and the 1928 Yale baseball team under head coach "Smoky" Joe Wood. As a center on the ice, Vaughan led the 1926–27 team with 25 goals, tying him for sixth on the single-season goals list in Yale history. A native of Newton, Massachusetts, he attended Newton High School and Andover. He coached the Princeton hockey team from 1935 until 1959, compiling 159 wins.

JOHN BENT '30s. John "Pleasure" Bent earned two varsity letters on the hockey team before playing for the U.S. team at the 1932 Olympic Winter Games, where it won the silver medal. Bent, a defenseman, was one of five Yale players on the Olympic roster in 1932.

DING PALMER '30. During Ding Palmer's 1927–28 season, he had an astounding 52 goals. No other Yale player has even had 30 goals in a season, and if assists were recorded during Palmer's first two seasons, he would likely be Yale's all-time points king (assists were not regularly recorded until his senior year). The left wing remains the school's top career goal-scorer with 87 tallies, even though he missed half of his junior season to illness. Palmer's three varsity years represent one of the best spans in Yale history as the Elis racked up a 46-6-2 record, including just one loss in each of his final two seasons. Palmer won a silver medal at the 1932 Olympic Winter Games in Lake Placid and is enshrined in the U.S. Hockey Hall of Fame.

HOLCOMB YORK '17. Yale's head coach from 1930 to 1938, Holcomb York compiled a record of 78-66-5. His most successful team was his first, in 1930–31, as the Elis racked up a 15-1-1 record. In 1917, York, a goaltender, was one of five leading Eli athletes to enlist for active duty in World War I when he joined the Marines. Before becoming head coach at his alma mater, he was assistant hockey coach from 1923 to 1930. York was also a writer (he and former Yale captain and Princeton coach Dick Vaughan wrote *Hockey—for Spectator, Coach and Player*, in 1939) and an artist (he studied painting in Paris and Florence).

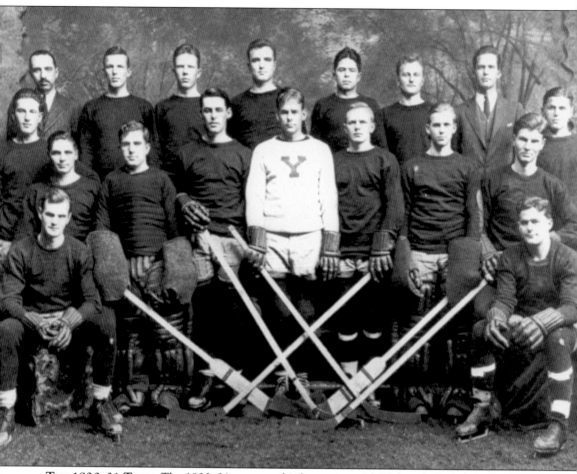

The 1930–31 Team. The 1930–31 team, under first-year coach Holcomb York, was one of the finest in school history. For the third consecutive season, the Elis lost just one game, rounding out the class of 1931's amazing three-year record at 47-3-3. Under York and captain Frank Luce, the Elis beat every college team it played (its only loss was to the Boston Hockey Club) thanks to the services of future Olympians John Cookman, Frank Nelson, and Franklin "Tot" Farrel.

JOHN COOKMAN '31. A star on a team of the early 1930s, John Cookman came to Yale from Englewood High School in New Jersey and Exeter. A tennis and football player at Yale as well, Cookman was one of five Elis to play for the Olympic hockey team at the 1932 Lake Placid games. The Americans took silver as Canada claimed gold.

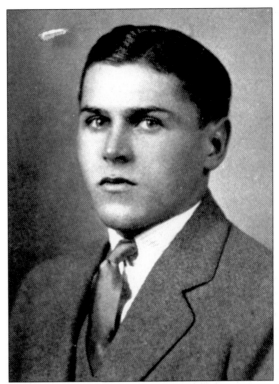

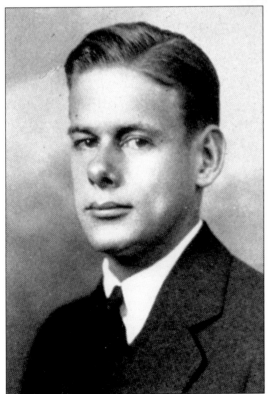

FRANK LUCE '31. Known by his classmates as "Egg Head," Frank Luce came to Yale from Andover, joining the illustrious hockey class of 1931. He and his teammates lost just one game in each of their three varsity seasons, thanks in large part to Luce. The leading scorer on the 1928–29 team with 13 goals, Luce also captained the 1930–31 Elis to a 15-1-1 record. Luce was one of the finest centers of his era, and he also played on the varsity tennis team.

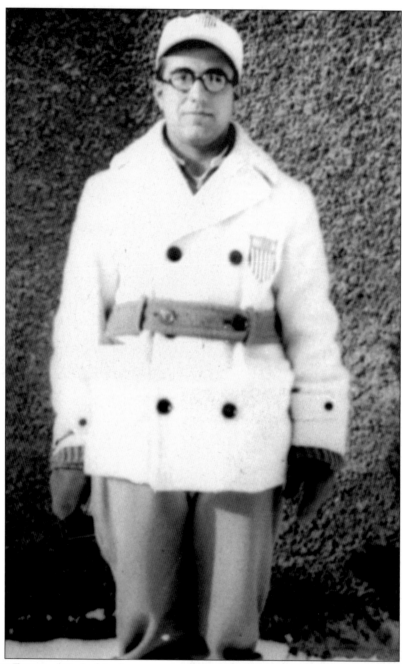

FRANKLIN FARREL '31. In his three years on the Yale varsity team, goaltender Franklin Farrel and his teammates lost only three games. The Elis racked up a 47-3-3 record between 1928–29 and 1930–31, many with Farrel in goal. After graduation, Farrel and four of his Yale teammates represented the United States at the 1932 Olympics in Lake Placid, where the Americans finished second to Canada. He is pictured here wearing his Olympic opening ceremony uniform. He went into the gear-drive business during World War II and remained in it afterwards, working in Ansonia and living in Woodbridge, just a few miles from the Yale campus. (Courtesy of Franklin Farrel.)

CHICK McLENNAN '31. Donald "Chick" McLennan led Yale in scoring in 1930–31, helping the Elis to a 15-1-1 record. One of the top wings in early Yale history, McLennan was a rare Midwesterner on the team, coming from Lake Forest, Illinois, via Hotchkiss. He also lettered on the Yale football team.

FRANK NELSON '31. A three-year letterwinner on the hockey team, Frank Nelson was one of five Yale players to compete on the ice at the 1932 Olympic Winter Games in Lake Placid. After graduating from Yale, he and his teammates took home a silver medal. Nelson hailed from Upper Montclair, New Jersey, and attended St. Paul's. He also played on the Yale soccer team.

JOHN MUHLFELD '32. A top defenseman, John Muhlfeld was captain of the 1931–32 Elis. Muhlfeld was invited to join several of his former Yale teammates to play in the 1932 Olympics, but he chose not to participate because he would have missed much of the Yale season. He also was a two-year letterwinner on the Yale football team. A native of Baltimore, Muhlfeld spent his working life in the airline industry before retiring in 1979.

KAY TODD '32. One of the best wings to play for head coach Holcomb York, Kay Todd (known as "Red") earned two letters, the first as a member of Yale's 15-1-1 team of 1930–31. He came to Yale from St. Paul Academy in Minnesota and lettered on the football team.

JACK WINTER '32. Like teammate John Muhlfeld, Jack Winter was an outstanding defenseman. The duo anchored the Eli backline in 1931–32, helping the Elis to their sixth straight winning season. Winter, who was from New York City and attended St. Paul's, won three varsity hockey letters.

JOHN SNYDER '35. The top Eli netminder for three seasons, John Snyder has the best career goals against average (2.58) in school history, and his 2.38 GAA in 1934–35 is fourth on Yale's single-season list. That year, he helped Yale to a Quadrangular League title as the Elis went 6-1 against league rivals Harvard, Princeton, and Dartmouth.

SID TOWLE '35. A star on both the Yale hockey and football teams, Sid Towle helped the Eli skaters to a Quadrangular League title in 1934–35. He was also named to the *Sports Illustrated* Silver Anniversary All-America football team in 1959. After graduation, Towle was freshman and assistant varsity hockey coach while a student at Yale Law School (he also coached the 150-pound football team). During World War II, he served as a lieutenant colonel in the U.S. Army as a member of the Transportation Corps. A graduate of Kent, he later served as the school's headmaster.

Two
THE MURDOCH ERA
(1938–1965)

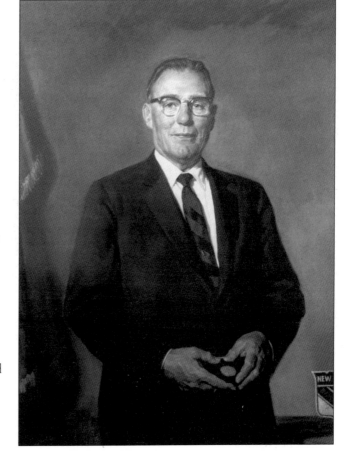

MURRAY MURDOCH. In many ways, Murray Murdoch was the father of modern Yale hockey. Though Yale had six coaches before him, none stayed with the program for more than eight years. Murdoch took over in 1938 and stayed for 27 years, compiling a 278-236-20 record with 15 winning seasons, two league titles, and a trip to the 1952 NCAA tournament. Only Tim Taylor has more wins as Yale head coach.

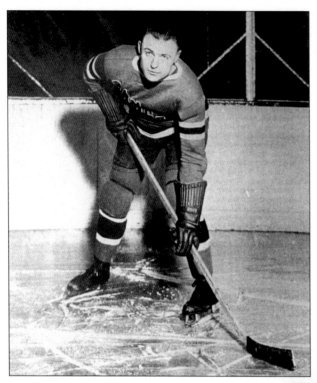

MURRAY MURDOCH. Murdoch's coaching career followed a distinguished NHL career. In 1926, he was the first player ever signed by the New York Rangers (left). He helped the Rangers to Stanley Cup titles in 1928 and 1933 and set an NHL record by playing in 563 consecutive games (including regular season and playoff contests). Newspapers referred to him as hockey's "Iron Man," and the "Lou Gehrig of Hockey." In 1974, he received the Lester Patrick Trophy for his contributions to American hockey. He was the oldest living NHL player until his death in 2001, two days shy of his 97th birthday. The photograph below is from Murdoch's days as head coach at Yale.

CYRUS VANCE '39. A three-year letterwinner on the hockey team, Cyrus Vance went on to one of the most visible and prominent careers of any hockey player in Yale history. Vance graduated from Yale Law School in 1942 and served in the U.S. Navy during World War II. He emerged from private law practice to serve as secretary of the army in 1961 and 1962. From 1964–67, he was deputy secretary of defense, and in 1968 was a U.S. negotiator to the Paris Peace Conference on the Vietnam War. He held his most prominent position, secretary of state, from 1977 to 1980, under Pres. Jimmy Carter. He became just the second secretary of state to resign for ideological reasons (William Jennings Bryan was the other, in 1915) because he opposed President Carter's handling of the Iran hostage crisis in 1980.

GILBERT HUMPHREY '39. Gilbert Humphrey was a top performer on the ice. He was captain and leading scorer (11 goals and 11 assists) of the 1938–39 Elis and a three-year letterwinner. But he achieved more fame on the football field. Among other gridiron feats, he threw a touchdown pass and kicked a field goal to beat Navy as a senior. In 1963, *Sports Illustrated* honored him and 24 other men with the Silver Anniversary All-America Award. His father, George M. Humphrey, was secretary of the treasury in the Eisenhower administration.

FRED BURR '40. Freddy Burr, a defenseman from Washington, Connecticut, captained the 1939–40 Elis to the Quadrangular League title with a 5-0-1 record against Dartmouth, Princeton, and Harvard. Those Elis were 11-6-4 and took a western trip to play Minnesota (two losses) and Michigan (a victory). Burr prepped for Yale at the Gunnery School.

HARRISON HOLT '40s. Yale's top goaltender for three seasons, Harrison Holt backstopped the Elis to a 1939–40 Quadrangular League title. Statistically, his best season was his sophomore campaign, when he posted 3.14 goals against average. His 3.87 career GAA is eighth on Yale's all-time list.

PETE PIERSON '41. A three-year letterwinner on defense, Pete Pierson served as captain of the 1940–41 Elis. That team rolled to a 12-4-2 record, including a near sweep of Colorado College and Minnesota on the road (Yale won two games at Colorado College and the first of two against the Gophers before suffering its first loss of the season).

CORD MEYER '43. The top goaltender on the 1941–42 Elis, Cord Meyer posted the fifth-best single-season GAA in school history (2.47). Meyer, whose twin brother Quentin was the second captain of the 1942–43 team, entered the U.S. Marine Corps in 1942. He lost his left eye in an attack on Guam and was later awarded the Purple Heart and the Bronze Star (Quentin was killed at Okinawa). Meyer worked at the Central Intelligence Agency from 1951 to 1977 and is known for being second-in-command of worldwide clandestine activities, as well as domestic actions informally known as "dirty tricks." Watergate historians have speculated that Meyer could have been "Deep Throat," but *Washington Post* reporters Bob Woodward and Carl Bernstein have ruled him out. Meyer's ex-wife, Mary Pinchot Meyer, was murdered in Washington D.C. in 1964. Soon after her death, a diary revealed that she had an affair with Pres. John F. Kennedy, adding her unsolved murder to the mystery of the Kennedy assassination.

WILLIAM WOOD '43s. Bill Wood owns an interesting distinction in Yale hockey history. He served as captain for just one game, a 19-1 drubbing of Boston University to start the 1942–43 season. After that, he went into World War II, flying 36 missions as a navigator in England. On the ice, Wood was a fast-skating left wing. When the war ended, Wood enrolled at Michigan Law School and went into private practice for almost 60 years in Hartford.

ARCHER HARMAN JR. '45. Archer Harman Jr. was a second-generation Eli hockey captain. The captain in 1943–44, he was a top forward who did not have the opportunity to truly shine because he played during World War II. He led the team in scoring as a junior and senior, but both seasons were shortened because of the war. He joined the Navy in February 1944, before becoming an educator. The rink at St. George's School in Newport, Rhode Island (where he was headmaster), is named for him.

ALAN PORTER '46. Alan Porter (pictured here with Murray Murdoch) earned three letters during wartime, playing in 1942–43 and 1943–44 before serving in the U.S. Navy. He returned to New Haven to captain the Elis in 1945–46, a shortened season in which Yale finished with a 6-2 record. That season included an 18-2 rout of Cornell in Yale's 700th game, a 14-0 pounding of Princeton, and a 9-2 smashing of Harvard to close the season.

TERRY VAN INGEN '45W. A three-year letterwinner, Terry Van Ingen first played goal on the varsity in 1942–43 before entering the service. He returned for the 1945–46 season, posting a 3.50 GAA, and was captain of the 1946–47 team that was 15-6-1. Those Elis ended the regular season tied with Dartmouth for the Pentagonal League title but lost a playoff game to the Hanoverians, 5-2, in Boston. Van Ingen grew up in Greenwich and also played on the Yale soccer team.

FRED PEARSON '47W. Since he was a youngster, Fred Pearson dreamed of representing the United States at the Olympics. At the freshman tryouts at Yale, Pearson knew that most of the other hopefuls would wear similar colored slacks and nondescript shirts, so he went out and bought a bright red flannel shirt; he could not bear the thought of being overlooked. Whether it was the shirt, his skills, or a combination of both, Pearson made the team and became one of the top left wings to play for Murray Murdoch (his junior and senior years were delayed by his two years in pilot training during World War II). After graduating, he achieved his lifelong dream, playing in the 1948 Olympics in St. Moritz, Switzerland.

ARTHUR MOHER '48. A top scorer, Arthur Moher notched consecutive 40-point seasons as a junior and senior. As a junior, he tied for the team lead with 43 points as the Elis finished 15-6-1, losing the Pentagonal League playoff game to Dartmouth. As a senior, he captained the team, pacing the squad with 21 goals and 19 assists. He also played across the diamond from first baseman, Yale captain, and future U.S. president George H.W. Bush as a shortstop on the baseball team. The Elis reached the College World Series in 1947 and 1948.

GORDON RITZ '49. Gordie Ritz led the 1946–47 Elis in scoring with 21 goals and 22 assists and was captain for the 1948–49 season. A rare four-year letterwinner, Ritz went on to help found the Minnesota North Stars of the NHL. Ritz led an investor group (which also included John Ordway '49, and Harry McNeely '45) that secured a team for Minnesota in 1967–68, the first year of NHL expansion. He served as the team's president from 1976 to 1978.

NORTHRUP KNOX '50.
Northrup Knox earned two letters on the Yale varsity but was known more for his role as an owner than a player. In 1969, Knox and his brother, Seymour Knox III, brought an expansion team—the Buffalo Sabres—into the NHL (the Sabres took the ice for the first time in 1970). Knox was also an outstanding polo and court tennis player. He is a member of both the U.S. Polo Association Hall of Fame and U.S. Court Tennis Association Hall of Fame.

JAMES BURNS '50. A three-year letterwinning goaltender, Jim Burns won 29 games, fourth-most on Yale's career list. His best season was his senior year, when he posted a 3.00 GAA.

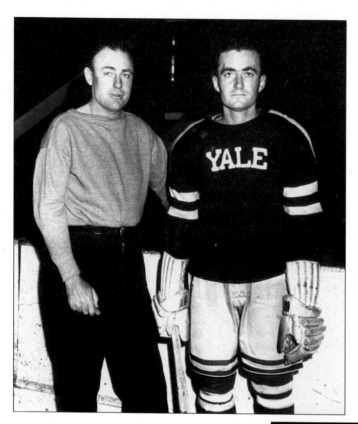

ALLEN CLAPP '50. Allen Clapp, the captain of the 1949–50 team, won a rare four letters in his Yale hockey career. Under his leadership, the 1949–50 Elis rebounded from consecutive losing seasons to post a 13-6 record. Clapp had his best offensive season in 1948–49, when he notched 29 points to finish third on the team in scoring. After leaving school, Clapp worked for 25 years for two manufacturing businesses before going into the executive search field for 20 years.

TOM MCNAMARA '51. Tom McNamara was an adept goal-scorer and playmaker who never posted fewer than 23 points in a season. His career culminated in his senior campaign in 1950–51, when, as captain, he led the team with 37 points (18 goals and 19 assists) skating alongside his former Hamden High School teammate and then-roommate, Ted Shay (23 goals). That year was one of the best in modern Yale history with a 15-2-1 record. After graduation, he went into manufacturing at Koppers Company in Baltimore.

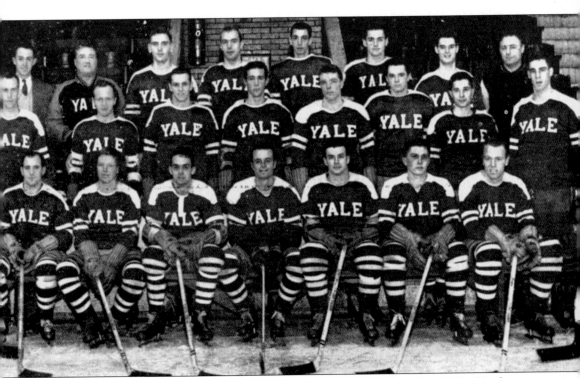

THE 1951–52 TEAM. Yale had a loaded team returning to New Haven in 1951–52 after a
15-2-1 season the year before. With the likes of all-time great scorers Ted Shay and Wally
Kilrea, the goaltending of Pete Cruikshank, and the leadership of captain Harry Havemeyer and
coach Murray Murdoch, the Elis had high hopes for the 1951–52 season. After a slow start to
the season, the Elis went on a western trip during which they split with Colorado College and
swept Minnesota. The Elis won 11 of their last 12 games and won the Pentagonal League.
Unlike the previous season, when Yale was snubbed by the NCAA tournament committee, the
Elis drew a postseason bid in 1952. After a win and a loss in the NCAA tournament, the Elis
finished with a 17-8 record.

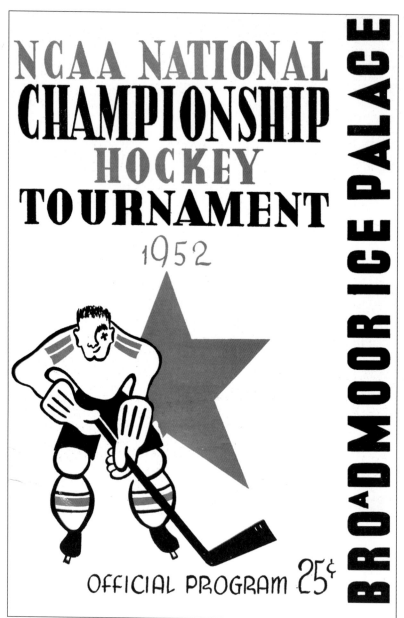

THE 1952 NCAA TOURNAMENT. In 1950–51, Yale had one of its best teams in modern times with a 15-2-1 record. At that time, the NCAA selection committee chose four teams for its postseason tournament—two from the East and two from the West. No one is quite sure how it happened, but Brown and Boston University were the teams chosen to go to the 1951 tournament. The following year, Yale had a 16-7 record, and controversy again surrounded the NCAA selection process—the committee decided to arrange a playoff between Yale, St. Lawrence, Boston University, and Boston College. When the Boston schools balked at the idea, Yale and St. Lawrence were named as the eastern representatives. Playing at the Broadmoor Hotel in Colorado Springs, the Elis drew Colorado College in the semifinals. Yale led 3-0 before struggling with the thin air, eventually falling 4-3. The Elis placed third, beating St. Lawrence in the consolation game, 4-1, and Michigan beat Colorado College for the title.

PAUL CRUIKSHANK '52. The last line of defense for two of Yale's best teams—the 1950–51 and 1951–52 Elis—was goaltender Pete (Paul) Cruikshank. In those years, Yale won 32 games, lost only 10, won a Pentagonal League title, and went to the NCAA tournament for the first time. Cruikshank, a Watertown native and a graduate of Exeter, was between the pipes in 31 of those wins. In 1950–51, he posted a 2.31 goals against average—still the second-best mark in school history. Playing without a mask (there were no helmets or masks then), Cruikshank managed to keep his face intact until the final game of his career, against Colorado College in the NCAA tournament, when his two front teeth were knocked out. After graduation, he worked in the railroad industry. One of his daughters, Lynn, played hockey at Yale and graduated in 1982.

TED SHAY '52. Ted Shay came to Yale from nearby Hamden to play for his father's old NHL opponent and friend, Murray Murdoch (Normand Shay played two seasons in the NHL). At Yale, Shay was an instant success on the ice, leading the freshman team to an undefeated record before pacing the varsity in scoring as a sophomore and junior. In 1950–51, he had 23 goals—the most since Ding Palmer's 27 in 1929–30. He now stands 10th on Yale's all-time scoring list, and other than Palmer, every player ahead of him played in the era of freshman eligibility. After graduation, Shay was in Japan during the Korean War as a member of the U.S. Army, alongside his teammate Harry Havemeyer. Shay, an artillery officer, was awarded the Bronze Star. He went on to University of Connecticut Law School and practiced law in the New Haven area for 40 years.

HARRY HAVEMEYER '52. Harry Havemeyer did a lot of winning in his hockey career. The captain of the 1951–52 Elis—Yale's first NCAA tournament team—spent two years on the St. Paul's varsity and never lost a game. His freshman team at Yale also went undefeated, and it was not until the sixth game of his sophomore year that his personal streak finally ended (a 4-1 defeat to eventual national champion Michigan). The Elis lost a few more in his career, but not many—his teams were 45-16-1.

LAWRENCE NOBLE JR. '53. Larry Noble Jr. assumed the role of Yale hockey captain 26 years after his father had served the team in that capacity. As a sophomore, Noble made the varsity but was considered an extra forward until Murray Murdoch gave him a chance to play in the fourth game of the year, replacing a veteran player in the lineup. Noble responded with a hat trick against Northeastern and was a mainstay in the lineup for the rest of his Yale career.

WALLY KILREA '54. Wally Kilrea had an outstanding Yale career, which came as no surprise to anyone who knew his family. His father, Wally Sr., played 16 years of professional hockey, including time in the NHL with five teams; two uncles, Hec and Ken, played in the NHL; and so did a cousin, Brian, who was also an NHL assistant coach with the Islanders for two years in the 1980s. At Yale, Wally was a two-time All-ECAC pick and never posted fewer than 33 points in a season. As a senior and team captain in 1953–54, he had 46 points, the most by a Yale player since Ding Palmer in 1927–28, and a total that would not be surpassed by another Yale player until Jack Morrison had 49, 13 years later. Despite only having the chance to play three varsity seasons, Kilrea is still tied for ninth on the Yale career scoring list with 115 points.

DIXON PIKE '54. Dixon Pike earned two varsity letters and finished in the top five on the team in scoring both seasons. As a senior, skating alongside Wally Kilrea and Leigh Quinn, he notched 10 goals and 19 assists. Pike came to Yale from the Belmont Hill School in Massachusetts, where he was captain of the team as a senior. He went on to work for Eastman Kodak, eventually ending up an executive in the company's real-estate division. One of his sons, Stephen, played junior varsity hockey at Yale and graduated in 1990.

LEIGH QUINN '54E. Playing on a high-scoring line with Wally Kilrea and Dixon Pike, Leigh Quinn was a solid offensive player on Yale teams of the early 1950s. His best year was his senior campaign, when he finished second on the team in scoring with 32 points behind only Kilrea. Quinn came to Yale after graduating from the Belmont Hill School in Massachusetts and spending a prep year at Andover. After Yale, he went into his family's chemical business, K.J. Quinn & Company, which was founded in 1880.

DICK WHELAN '54. Sandwiched between two of the great goaltenders in Yale history, Dick Whelan had a good season of his own, in 1952–53, when he posted a 2.62 goals against average. That mark ranks him sixth on the single-season GAA list in school history. He earned his first letter that season (when Yale was 13-8) and earned another the following year, when the Elis were 12-5-3. Whelan came to Yale from South Side High School in Rockville Centre, New York, and the Mount Hermon School.

GEORGE BROOKE JR. '55. George Brooke Jr., the captain of the 1954–55 Bulldogs, had one of the most prolific nights in Yale history on January 15, 1955. In an 8-0 win over Army at the New Haven Arena, the winger tallied five goals and two assists, setting single-game goals and points records for a Yale senior. Brooke came to Yale from Reading, Pennsylvania, and prepared for Yale at St. Paul's. His father, G. Clymer Brooke, was a 1928 graduate of Yale and a rower.

DAVID S. INGALLS '56. A famous name to Yale hockey fans, David S. Ingalls Jr. and his father have been the namesakes for Yale's home rink since 1959. Ingalls, whose father was captain of the 1918–19 and 1919–20 Elis, served as captain in 1955–56. That season, Yale was 9-10. Ingalls grew up in Cleveland and prepped for Yale at St. Paul's. Like his father, he was a pilot in the U.S. Navy, serving on the U.S.S. *Midway*. When he got out of the service, he earned an M.B.A. from Stanford and was later a founder of the Grumman American Aviation Corporation. He served for 14 years as the director of the Cleveland Museum of Natural History (the museum's highest honor is the David S. Ingalls Jr. Memorial Award), and he was chairman of the Ohio Republican Finance Committee. The new rink at St. Paul's is also named for him.

JOHN AKERS '56E. John Akers came to Yale from Needham High School in Massachusetts. When he got to Yale, legendary swim coach Bob Kiphuth wanted Akers for the swim team, but he was too devoted to hockey to make the switch. He had a solid career at Yale, leading the team in scoring with 29 points (16 goals and 13 assists) in 1955–56, earning second-team All-Ivy honors. He also scored the only goal in a thrilling 1-0 win over Harvard at the New Haven Arena in his final home game. Following graduation, he was an aviator in the U.S. Navy for four years, including seven months on the U.S.S. *Lexington* in the South Pacific, before entering the sales training program at IBM in 1960. He remained at IBM for 34 years, culminating with his election as chairman of the board and chief executive officer in 1985. He served in those capacities until 1993.

KEN MACKENZIE '56E. A two-sport star at Yale, Ken MacKenzie was the leading scorer on the hockey team as a junior as well as the captain of the baseball team as a senior. The native of Gore Bay, Ontario, led the Eli skaters with 20 points (13 goals and 7 assists) in 1954–55, before earning second-team All-Ivy honors as a senior. After leaving Yale in 1956, MacKenzie went on to a six-year career as a pitcher in Major League Baseball. Remarkably, he was 5-4 with the 1962 Mets—at 40-120, the worst team in modern-day baseball history. He was the only pitcher to have a winning record on the original Mets. Following his retirement from professional baseball, MacKenzie returned to Yale in 1967 to become the freshman baseball and hockey coach. He was the varsity baseball coach from 1969 to 1978.

49

GEORGE SCHERER '56. Early in his sophomore season, goaltender George Scherer had to find out from the *Yale Daily News* that he was going to make his first varsity start—Murray Murdoch hadn't bothered to tell him. So it was a shock to just about everyone when the unheralded St. Paul's graduate shut out Boston University at the Boston Garden in his first varsity game. Scherer, who also had a memorable performance in a 3-2 win at Boston College as a junior, went on to a remarkable career that included All-ECAC and first-team All-Ivy honors in 1955–56. That year, he posted three shutouts, including a 1-0 win over Harvard at the New Haven Arena. He still stands atop the Yale career rankings in save percentage (.899) and is fourth in career GAA (3.46).

JOHN POINIER '57. The captain of the 1956–57 team, John Poinier has left behind a legacy of outstanding defensive play. Every year since 1981, Yale's top defensive player has received the John Poinier Award. A second-team All-Ivy pick in 1955–56, Poinier was a blue liner on the Yale varsity for three seasons. A native of Short Hills, New Jersey, Poinier's father also attended Yale and graduated in 1934.

RICHARD STARRATT '58. A three-year letterwinner, Richard Starratt was captain of the 1957–58 Elis, who finished 8-12-2. One of his most memorable games was a 4-4 tie with Army at the New Haven Arena in his senior year, when he went up against cadet captain Mike Harvey, a former teammate at Andover. Following four years in the U.S. Navy, Starratt went on to a 40-year banking career, most of it spent with J.P. Morgan and Wells Fargo. (Photograph by M.A. Gordon.)

Tom Goodale '59e. Tom Goodale, the captain of the 1958–59 Elis, was a two-time All-Ivy pick and led the team in scoring as a junior with 32 points (16 goals and 16 assists). Goodale was also second on the team in scoring as a senior with 26 points (14 goals and 12 assists) as the team finished with a 12-9-1 record. He was a first-team All-Ivy selection as a junior and made the second team as a senior. Goodale came to Yale from Taft, although he spent one year of high school at Highland High in Albuquerque, New Mexico, where he won a hockey state title. Among his senior hockey highlights were trips to China and the Soviet Union and playing in a United States versus Sweden all-star game at Madison Square Garden, where he scored a goal off a pass from 1980 Olympic hero Mike Eruzione.

GERRY JONES '59. Unlike most goaltenders who learn to play the position as young kids, Gerry Jones did not learn to play in goal until his sophomore year of high school. He learned, of all places, in his family's garage in Greenwich. His late start obviously did not hurt him, as he went on to become Yale's first All-American, in 1958-59. The starter in New Haven for three years, Jones had some memorable performances as an Eli, particularly his then-school-record 66 saves against St. Lawrence in 1957–58 and his 50 saves in a 3-1 win over Boston University in 1958–59. He averaged more than 40 saves per game over his career. After graduation, he went on to Yale Law School before embarking on a law career in New York and Connecticut.

ED McGONAGLE '60. Ed McGonagle was Yale's first two-time first-team All-Ivy pick (1958–59 and 1959–60) and notched at least 30 points in each of his three varsity seasons. He peaked in 1959–60 when he led the team with 38 points (17 goals and 21 assists). Also the leading scorer in 1958–59, McGonagle finished his career with 104 points. After graduation, he spent three years in the U.S. Navy, including a year in Seoul, South Korea. His time there sparked an interest in Asia, and after returning to the United States, he earned a master's degree in Asian history in 1972 from Georgetown. He worked most of his career for the navy but also spent three years teaching history at Princeton Day School. He has continued to play hockey, including stints with St. Nicks and a senior club team, the Gerihatricks, with which he has played in three Senior Olympics.

BRUCE SMITH '60. A top defenseman, Bruce Smith was in the lineup for every single game of his varsity career. He was captain of the 1959–60 Elis, who beat Harvard on the road to wrap up the season. After graduation, he played on a professional team in Paris that took on such opponents as the Czech national team. He went on to become a sculptor and screenwriter and has co-written a screenplay based on the life of Hobey Baker.

CHARLES HAMLIN '61. A two-year letterwinner, Charles Hamlin took over as starting goaltender after the graduation of All-American Gerry Jones. Hamlin carved out a nice legacy of his own, setting the Yale career shutouts record with five, a mark that still stands. Hamlin went on to become a renowned orthopedic surgeon specializing in hands. He received the 2001 Humanitarian Award from the American Academy of Orthopaedic Surgeons for his work establishing the Chinle Hand Clinic in Arizona.

KEN MACLEAN '61. The captain of the 1960–61 Bulldogs, Ken MacLean played all but one game in his three-year varsity career. A native of Toronto, MacLean earned second-team All-Ivy honors as a senior. Along with John Schley and Tom Edwards, he wanted to be the first person on the ice at the brand-new Ingalls Rink in the fall of 1958. But the trio soon found that George Robinson, '60, had beaten them to it (Robinson had skipped a class). After graduation, MacLean practiced architecture for 27 years with his own firm and played on a masters hockey team that played in the Soviet Union, Finland, China, Czechoslovakia, and Manchuria— where it was 15 degrees below zero.

DAVID CROSBY '62. David Crosby captained the 1961–62 Elis and led the team in goals his junior year with 13. As a sophomore, he and his brother Tom (class of 1960) skated on the same line—a rarity in Yale hockey history. Off the ice, Crosby and his teammates were victims of the hustling tactics of the team trainers when they played cribbage in the locker room.

STEVE RIPLEY '62. Steve Ripley was the first Yale defenseman to earn first-team All-Ivy honors, in 1961–62, when he led the Elis in scoring with 29 points (11 goals and 18 assists). He wound up with 64 career points, the most of any defenseman in Yale history to that point. His record stood for 21 years (until it was broken by Bill Nichols), and his 64 points now rank sixth in Yale defenseman history. He also had a seven-point game (four goals and three assists) against American International College in 1962.

BILL HILDEBRAND '63. An outstanding playmaker, Bill Hildebrand was a top forward on some very good Yale teams. As captain his senior year, Hildebrand led the team in assists with 27 (and he added 10 goals) as the Elis posted a 13-9-1 record. He also led the team in scoring with 24 points in 1960–61, when Yale again had a winning record of 13-12-1. His brother, Dick, is now an assistant equipment manager at Yale.

COLEMAN BURKE '63. A second-team All-Ivy pick along with Frank Bishop in 1962–63, Coleman Burke had 13 goals and 14 assists that year. Burke, who attended the Pingry School in New Jersey, as well as St. Paul's, transferred to Yale from Hamilton College.

FRANK BISHOP '64. Frank Bishop was a second-team All-Ivy pick in 1962–63 after leading the Elis with 38 points on 20 goals and 18 assists. That season, Yale was 13-9, the last winning team under Murray Murdoch. Bishop, a graduate of Mamaroneck High School in New York, earned varsity letters in 1960 and 1963.

TOBY HUBBARD '64. A hard-hitting defenseman from Long Island, Toby Hubbard was the captain of the 1963–64 Bulldogs as well as a two-year letterwinner on the football team. After performing as Yale's top punter on the gridiron in 1963 (he also played tight end and defensive end), he was a second-team All-Ivy defenseman on the ice as a senior. Hubbard entered the Yale-China program after graduation, teaching English to Chinese university students in Hong Kong for two years. He went on to earn graduate degrees from Wesleyan and Harvard and has been a high school English teacher at Walpole High School in Massachusetts since 1972.

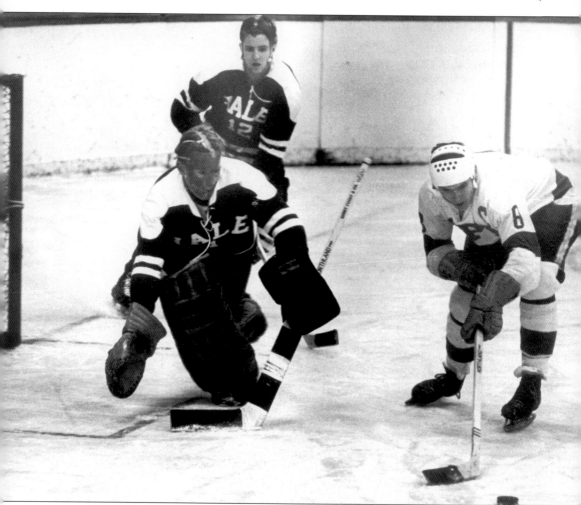

MIKE HANSON '65. The last captain under Murray Murdoch, goaltender Mike Hanson barely left the nets in his last two years at Yale, playing every game as a senior and all but two as a junior. He came of age in a sophomore year win over Brown at Ingalls Rink in which the Elis upset the Bruins on the back of Hanson's 39 saves. He went on to set the school record for career saves with 1,845—a record that stood for 15 years (he is now seventh on the list). After graduation, Hanson went on to own several radio stations in New York and Connecticut. He also created the Yale Hockey Hotline in 1981, updating Yale fans through the use of an early-generation answering machine in his home—a predecessor to the Yale Sports Hotline.

Three
Between the Legends (1965–1977)

Richard Gagliardi. The Yale varsity head coach for eight years, Dick Gagliardi compiled a record of 60-105-2, highlighted by a 13-11 campaign in 1966–67. He took over the program in 1965, succeeding Murray Murdoch, who had been at the Yale helm since 1938. Gagliardi was a former football standout and All-East hockey player at Boston College who graduated from the school in 1956. He coached the Yale freshmen for several years before taking on the head varsity job.

DICK WILLIAMSON '66. A defenseman who missed only two games in his three-year varsity career, Dick Williamson was captain of the 1965–66 Elis, a team that beat Harvard three times (including in the finals of the Nichols Tournament in Buffalo, New York). A Yale team had not defeated the Crimson three times in a season since 1901–02 or even twice in 14 years. Williamson went on to join the faculty at Bates College as a French professor.

WARREN GELMAN '67. Warren Gelman was the captain of the 1966–67 team, as well as the undefeated freshman team of 1963–64, one of the best in Yale history. He earned three letters and racked up 88 career points. As a senior, Gelman led the Elis to a 13-11 record, including a win over Cornell. It was the eventual national champions' only loss of the season. Now a lawyer in Buffalo, Gelman and classmate Jack Walsh were cochairs of the local organizing committee for the 2003 NCAA Frozen Four in Buffalo.

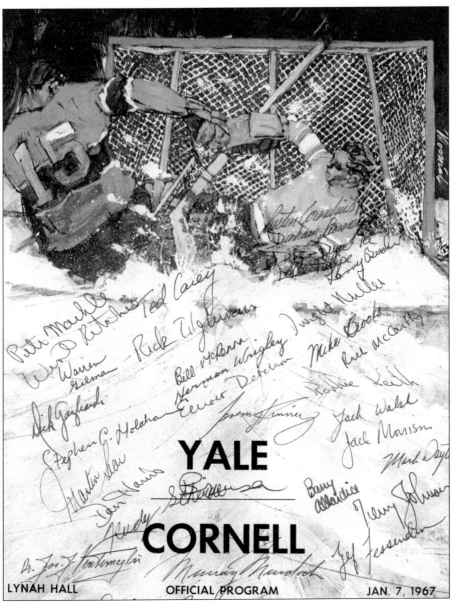

YALE

CORNELL

LYNAH HALL OFFICIAL PROGRAM JAN. 7, 1967

YALE AT CORNELL, JANUARY 7, 1967. When Yale arrived at Lynah Hall in January 1967, Cornell was undefeated and ranked first in the country. With an array of talent, including goaltender Ken Dryden, forward Doug Ferguson, and defenseman Harry Orr, Cornell figured to blow past the Elis. Cornell coach Ned Harkness played backup goaltender Dave Quarrie, and Yale had solved him; at the end of regulation, the score was tied 3-3. In the extra session, Yale sophomore goaltender Steve Holahan made a game-saving stop with the butt of his stick. Later, in an amazing individual performance, Yale All-American Jack Morrison stole the puck from Orr, skated through the Cornell defense, and scored on Quarrie to give Yale an exhilarating 4-3 win. Apart from the dozen or so Yale fans in attendance, Lynah was left silent, and the goal judge was so demoralized that he never even turned on the red light—he just left. For Cornell, the loss was the team's only defeat of the season as it rolled to a national title; for Yale, it was one of the most treasured victories in school history. (Courtesy of Dwight Miller.)

JACK MORRISON '67. Jack Morrison—known on campus as "the Boomer"—came to Yale as a heralded schoolboy player. *Life Magazine* called him "the best high school player in America" at Andover. He lived up to the hype, becoming Yale's all-time leading scorer with 119 points on 51 goals and 68 assists. More than 35 years after his Yale career ended, Morrison still stands eighth on the school's scoring list, and all seven players ahead of him played in the era of freshman eligibility. As a senior, he racked up 49 points—the most of an Eli skater since 1928— and was Yale's first All-American in eight years. Morrison went on to become Yale's first Olympic hockey player since Fred Pearson in 1948. He led the United States in scoring at the 1968 Olympic Winter Games in Grenoble, France.

DWIGHT MILLER '67 AND MICHAEL BROOKS '67. The foundation of the Yale defensive corps in the mid-1960s began with pair of prep school rivals who, when they came to New Haven, had no interest being teammates. Mike Brooks, the former captain at Kent, and classmate Dwight "Moose" Miller, the former captain at Hotchkiss, overcame their schools' enmity, finding they could not only coexist as teammates, but also as a frequent defense pairing and best friends. The duo appeared in a combined 132 games as they both earned three varsity letters. Brooks was also a key member of the last undefeated men's tennis team in Yale history, in 1967. Brooks returned to Yale in 1970–71 as an assistant hockey coach before embarking on a career as an investment banker and venture capitalist. Miller has worked in the legal field in New York, St. Louis, and Palm Beach.

JACK WALSH '67. A member of one of the most potent forward lines in Yale history, Jack Walsh was a three-year standout on the Eli varsity who twice led the team in goals. The trio of Walsh, All-American center Jack Morrison, and Walsh's high school teammate, Warren Gelman, combined for 283 points over three seasons. A knee injury ended the speedy wing's season prematurely in 1966–67, limiting him to just 12 games. He and Gelman were cochairs of the local organizing committee for the 2003 NCAA Frozen Four in Buffalo.

BARRY ALLARDICE '68. Barry Allardice was a rarity—he came to Yale from Chatham High School in northern New Jersey, a school and a place not noted for its hockey prowess in the mid-1960s. At Yale, he earned three varsity letters and was captain of the 1967–68 team, tying for the team lead in scoring with 20 points that year. After three years in the U.S. Navy, Allardice attended Harvard Business School before working on Wall Street until his retirement.

ROLAND BETTS '68. Roland Betts earned just one varsity letter, but he has gone on to a notable career after Yale. His book chronicling his experiences as a teacher, *Acting Out: Coping with Big City Schools,* became a bestseller. He practiced entertainment law in New York before going into film financing and production. In the sports world, Betts was lead owner of the Texas Rangers (along with George W. Bush, among others) from 1989 to 1994. He is also a member of the U.S. Olympic Committee and the Yale Corporation and is director of the Lower Manhattan Development Corporation.

MARK DAYTON '69. A two-year letterwinner, Mark Dayton backed up Steve Holahan in goal for two years, appearing in 12 games over his career. But while Dayton was not a standout on the ice at Yale, he has stood out in public service. In 2001, Dayton was elected to the U.S. Senate from his home state of Minnesota. Prior to his election to the senate, Dayton served on the staffs of Sen. Walter Mondale (1975–76) and Minnesota governor Rudy Perpich (1977–78).

67

STEVE HOLAHAN '69. As the 1966–67 season began, sophomore goaltender Steve Holahan was fourth on the varsity depth chart. Less than a month into the season, however, he was unexpectedly thrust into a game at Rensselaer Polytechnic Institute (RPI) midway through the second period with Yale trailing, 6-3. With his head spinning from the surprise of entering the game, the first Engineer shot hit his blocker and ricocheted off his chin, waking him up and focusing him on the rest of the game. RPI led 7-4 at the start of the third, but a furious Eli comeback, keyed by the heroic efforts of Jack Morrison, gave Yale a shocking 11-9 win. The game entrenched Holahan in the Yale nets for the rest of his career, which included the miraculous overtime win over Cornell later that season and a 3-2 overtime win over Harvard in his last game.

ED WRIGHT '70. The captain and leading scorer of the 1969–70 Bulldogs, Ed Wright was a steady offensive presence in his three varsity seasons, finishing with 26 goals and 27 assists. After Yale, Wright went to Tufts Medical School and later specialized in cardiology. Wright was a standout player at Boston's Catholic Memorial High School. In 2003, the Yale hockey team created an award in his memory, rewarding the combination of success on the ice and in the classroom (the first recipient was Denis Nam).

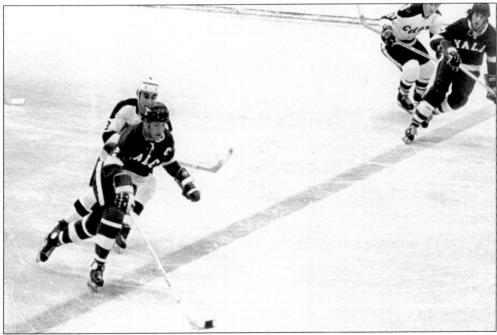

JOHN ORMISTON '71. A defenseman from Marblehead High School in Massachusetts, Ormiston was a cornerstone of the 1967–68 freshman team that was 19-1. He went on to captain the 1970–71 Elis and was a second-team All-Ivy selection a year earlier. He was the team's top-scoring defenseman as a junior and senior, and after graduation took his talents to Europe, playing for the top professional team in Holland (he played against the Soviet national team twice). Knee injuries ended his playing career, but he has been an important fundraiser for the Yale hockey program. (Photograph by Sabby Frinzi.)

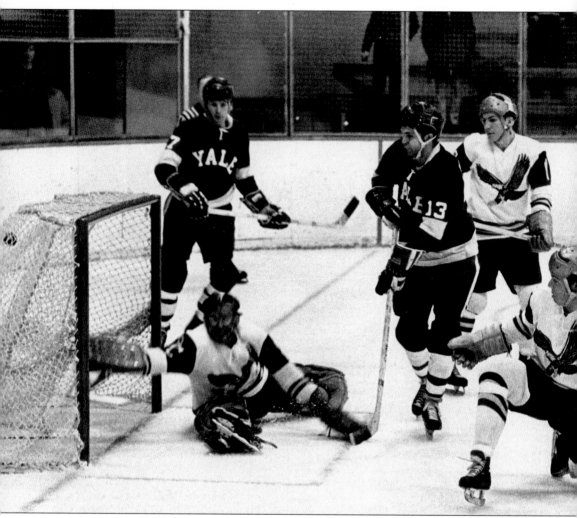

BOB UFER '71. Before he was known as the "Skating Commissioner," Bob Ufer, No. 13, was a Yale forward who as a sophomore led the 1968–69 team with 17 goals and 27 points. He wrapped up the season in dramatic fashion, scoring the game-winning goal to beat eventual NCAA semifinalist Harvard, 3-2. After his outstanding sophomore year, Ufer was limited to 22 games over the next two seasons because of a chronic shoulder injury. He went on to Harvard Law School and became the legal counsel of the International Hockey League. He served the IHL in that capacity until 1994, when he took over as commissioner of the league, a position he held until 1998. His father, Bob Ufer Sr., was the beloved radio voice of Michigan football for 37 years and held the indoor world record in the 440-yard dash (48.1 seconds) for three years in the 1940s. (Photograph by Milton M. Smith.)

JOHN COLE '71. Goaltender John Cole was one of the anchors of the heralded class of 1971. In his three varsity seasons, he wound up with 1,592 career saves (ninth in Yale history). Cole went on to play and coach in Europe, making stops in France, Switzerland, and Spain. He also briefly landed in a Prague prison in 1972 when he was arrested by the Czech secret police for climbing up a flagpole and ripping down the Soviet flag at the 1972 World Hockey Championships. He later returned to France to serve as a guide and interpreter for the U.S. delegation at the 1992 Olympic Winter Games in Albertville.

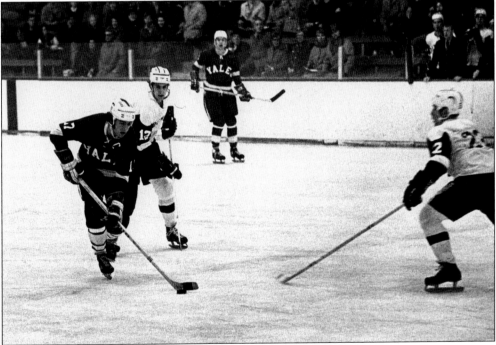

ROGER DEMMENT '72. A top scorer on Yale teams in the early 1970s, Roger Demment was captain of the 1971–72 Elis. He led the team in goals as a junior in 1970–71 with 12 and had 26 points in each of his final two seasons. After his Yale career, he was a player and coach for seven seasons in the French National League. Back in the States, he was head coach at Dartmouth from 1991 to 1997, earning 1992–93 ECAC Coach of the Year honors. (Photograph by Sabby Frinzi.)

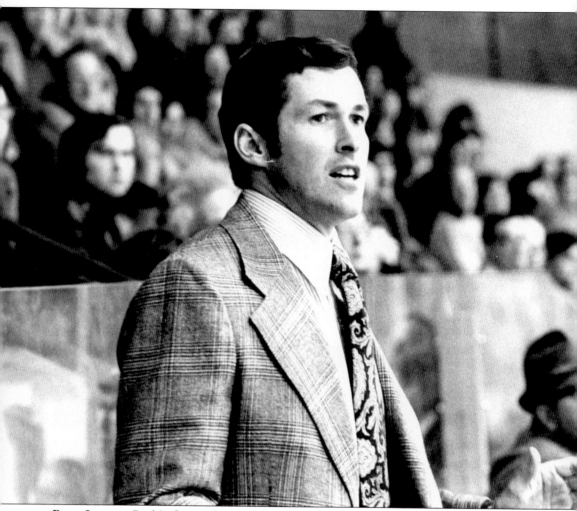

PAUL LUFKIN. Paul Lufkin took over as head coach of the Bulldogs in 1972. He was a former standout at Boston College, like his predecessor Dick Gagliardi. A native of Gloucester, Massachusetts, Lufkin was a three-year letterwinner at Boston College, graduating in 1964. He coached the Princeton freshmen for two years before taking the head varsity job at Yale. He led the Elis for four seasons, compiling a 25-68-2 record. His most successful team was his first, in 1972–73, when the Elis were 12-10-1. (Photograph by Sabby Frinzi.)

DEAN BOYLAN '73. A defenseman from Boston, Dean Boylan was an outstanding blue liner who captained the 1972–73 Bulldogs. That team posted a 12-10-1 record in head coach Paul Lufkin's first season. He came to Yale from Milton Academy and notched four goals and 30 assists as an Eli. After graduation, he became the first Yale player to reach the top level of professional hockey, playing for the New York Golden Blades of the World Hockey Association in 1973–74. With a few teammates in attendance at Madison Square Garden, Boylan got into a scrap with Gordie Howe, then a 45-year-old with the Houston Aeros. He also battled with Bobby Hull, afterwards skating to the bench and thinking, "Wow, that was Bobby Hull!" Boylan now coaches the varsity hockey team at Andover. (Photograph by Sabby Frinzi.)

DON CRAIG '73. At 6-foot-2, 205 pounds, Don Craig was an imposing presence for three years on the Yale blue line who missed just one game in his career. He finished his career as the top scoring defenseman in Yale history with 43 points (with 10 goals and 33 assists, he is now tied for 11th). A native of North Bay, Ontario, Craig went on to play two seasons of minor league hockey. (Photograph by Sabby Frinzi.)

BOBBY KANE '74. The captain of the 1973–74 Elis, Bobby Kane is Yale's hat trick king, racking up a school record seven over the course of his career. He set the single-season hat trick mark in 1972–73, when he had four such games. In a 9-7 win over Pennsylvania in December 1972, Kane had four goals and three assists while his roommate Phil Clark tied the school record with six assists. In 1972–73, Kane was the first recipient of the Murray Murdoch Award, presented to Yale's most valuable player. (Photograph by Sabby Frinzi.)

D'ARCY RYAN '75. A 1972 Montreal Canadiens draft pick, D'Arcy Ryan twice led the team in scoring, including his sophomore campaign in 1971–72, when he had nine goals and 27 assists while also leading the team with 79 penalty minutes. As a senior in 1974–75, he again led the team in points (25) and penalty minutes (93) while earning team MVP honors. He stands second on the Yale career scoring list for defensemen with 84 points on 22 goals and 62 assists. (Photograph by Sabby Frinzi.)

KEN MACKENZIE '75. A three-year starter in goal, Ken MacKenzie (not to be confused with Ken MacKenzie '56) was once called "the best goalie in United States college hockey" by Cornell head coach Dick Bertrand after he made 38 saves in a 5-2 win over the Big Red in 1974. A native of Sault Ste. Marie, Ontario, MacKenzie was a second-team All-Ivy pick in 1972–73 and was on the first team in 1973–74. He is eighth on the Yale career saves list with 1,731. (Photograph by Sabby Frinzi.)

DAVE BUCHAR '75. A three-year letterwinner, Dave Buchar captained the 1974–75 team, which won only one game. In that frustrating season, the Bulldogs lost in overtime to Dartmouth and Penn, and lost other one-goal affairs to Princeton, Harvard, and Brown. A center from Schumacher, Ontario, Buchar had 38 career points in 63 games and notched a hat trick—including the game-winning goal—in a 5-4 overtime win over Brown in his junior year.

KEITH MILLER '76. The captain of the 1975–76 Elis (the last team to play under head coach Paul Lufkin), Keith Miller earned three letters as a defenseman on the Yale varsity. The native of Cambridge, Massachusetts, notched nine goals and 28 assists in his career.

Four

THE TAYLOR ERA (1977–PRESENT)

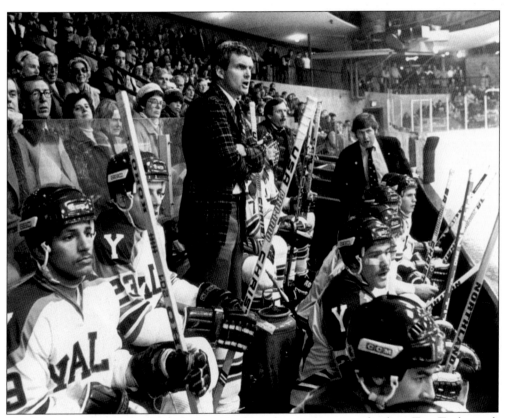

TIM TAYLOR. One of the most distinguished coaches in American hockey, Tim Taylor took over the Yale program in 1976, has won more games than any other Yale coach and has coached in more games than any coach in ECAC history. In 25 years, his teams have won six Ivy League titles and an ECAC crown, and he has been AHCA National Coach of the Year once and the ECAC Coach of the Year three times.

TIM TAYLOR. Taylor (left) came to Yale from Harvard, where he captained the 1963 Ivy and ECAC champion Crimson. He spent seven seasons as an assistant coach at his alma mater (and also played for the U.S. national team in 1965 and 1967) before taking over the Yale program. Despite his Boston roots and his Harvard pedigree, Taylor has become a true Yale Man. Since coming to Yale, Taylor has not only coached some of the best teams in school history, including the 1985–86 team that won 20 games and the 1997–98 squad that won the ECAC championship, but he has also served as head coach of the U.S. Olympic team in 1994 and was an assistant coach with the American team at the 1984 Olympics. Below, he celebrates the 1998 ECAC title with captain Ray Giroux.

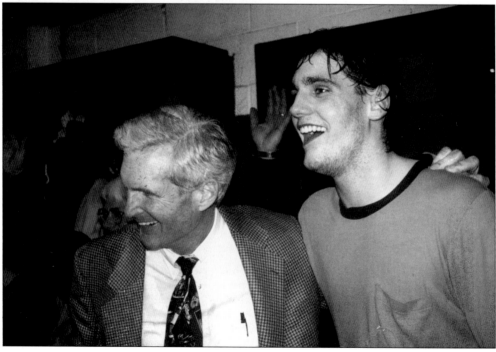

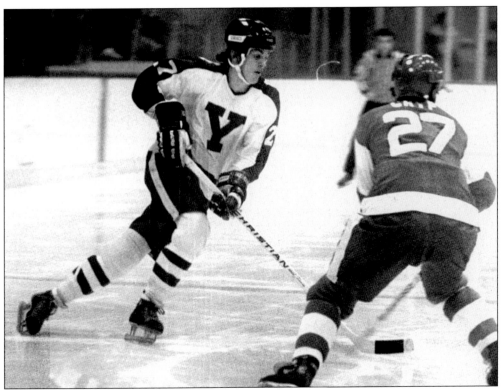

MIKE THOMAS '77. The first player to twice win the Murray Murdoch Award as the team's most valuable player, Mike Thomas was also the first captain under Tim Taylor, in 1976–77. He was named the team's top player in his junior and senior seasons, when he led the team in scoring. A native of St. Paul, Minnesota, Thomas racked up 51 goals—which tied him for third behind Ding Palmer and Ted Shay on the Yale career goals list when he graduated—to go along with 37 assists. (Photograph by Sabby Frinzi.)

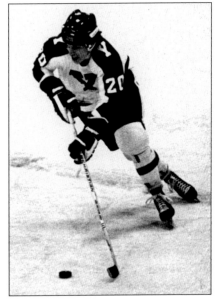

DON BLUE '78. Don Blue was captain of the 1977–78 Elis, the team that began to turn the Yale program around in Tim Taylor's second season as head coach. Under the leadership of Taylor and Blue, Yale beat eventual national champion Boston University and ECAC champion Boston College. Those Elis also swept Harvard and Princeton, a feat not repeated by a Yale team until 1998. Blue, a forward, finished his career with 22 goals and 44 assists in three varsity seasons.

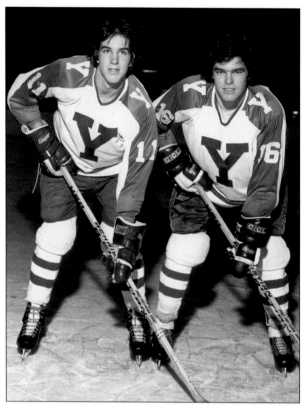

DAVE HARRINGTON '78. Dave Harrington (on the right in this photograph with his brother, Steve) led a surge of Rhode Islanders on the Yale roster in the late 1970s, including his younger brother, Steve, Jim Macdonald, Mike Cerrone, and Jim Murphy. The Harrington boys could be found all over the sports map at Yale and made history. Dave, Steve, and younger brother, Gerry, all earned varsity letters on the 1978 baseball team. Likely, it was the only time such a trio simultaneously played on the same varsity sports team at Yale. Dave, the oldest, scored the game-winning goal in one of the most memorable contests in Yale history, the "College Hockey Upset of the Decade" (according to *Sports Illustrated*), in which the Bulldogs upset top-ranked and eventual national champion Boston University in 1978. (Photograph by Sabby Frinzi.)

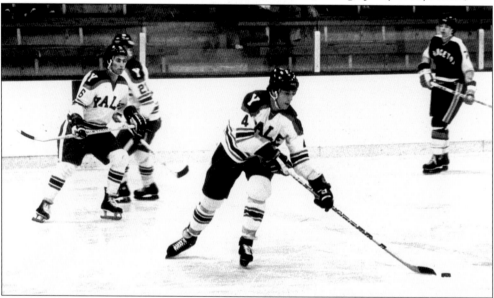

KIRK BRANSFIELD '79. Kirk Bransfield was one of the best defensive-defensemen at Yale in the late 1970s. A second-team All-Ivy pick in 1978–79, Bransfield played 88 games and recorded five goals and 18 assists. In the "College Hockey Upset of the Decade," Bransfield put Yale ahead of Boston University late in the third period, 5-4. Seven seconds later, Dave Harrington increased Yale's lead to 6-4, and the Bulldogs went on to win, 7-5. (Photograph by Sabby Frinzi.)

BILL CONWAY '79. Billy Conway grew up a speed skater in Minnesota, losing once in junior high to a kid from Wisconsin named Eric Heiden. The Yale captain in 1978–79, he was invited to try out for the 1980 Olympic hockey team but could not after tearing a knee ligament. A musician, Conway would often miss gigs for games, and after graduation, he turned his attention from hockey to music. He played as a drummer in the well-known Boston band Treat Her Right before joining Morphine. (Photograph by Sabby Frinzi.)

GARY LAWRENCE '80. Gary Lawrence ensured he would stay on new head coach Tim Taylor's good side forever when he scored the game-winning goal in the first game for both of them at Yale—a 3-2 win over Penn. Lawrence went on to become captain of the 1979–80 Elis. That year, the Rhodes Scholar took the ceremonial opening face off in Yale's game with the 1980 U.S. Olympic team, against American captain Mike Eruzione. He now promotes the sport in Hong Kong, where he runs a capital investment group. (Photograph by Sabby Frinzi.)

KEITH ALLAIN '80. When Tim Taylor took over the Yale program in 1976, the Elis had struggled to five wins over the previous two seasons and had not won an Ivy League game in nearly three years. In his first game as head coach, he threw a freshman goaltender, Keith Allain, between the pipes. Taylor's first personnel decision turned out to be a good one as Allain backstopped Yale to a 3-2 win over Penn. Allain remained entrenched in net, setting Yale records for games played (78), career saves (2,422), and tying the school record for career wins (31) as Taylor revived the foundering program. Though Allain's records have since been broken, he has continued to leave his mark in hockey as a coach on the international level and in the NHL. (Photograph by Sabby Frinzi.)

PAUL CASTRABERTI '81. A dynamic scorer early in his career, Paul Castraberti was the first of only four freshmen in Yale history to lead the team in scoring. As a rookie in 1977–78, he paced the squad with 26 points. The following year, he was named team MVP and second-team All-Ivy as he again led the team in scoring with 40 points. In his final two years, however, injuries limited him to just 29 games, although he still managed to post 35 points in those years. For many of those games, his friend and junior varsity player Kim Campbell could be heard rousing the Ingalls Rink crowd, beating out a pounding rhythm on a cowbell. Castraberti went on to run his family's Italian restaurant in Saugus, Massachusetts, a frequent stop for the traveling Yale hockey team on road trips. (Photograph by Sabby Frinzi.)

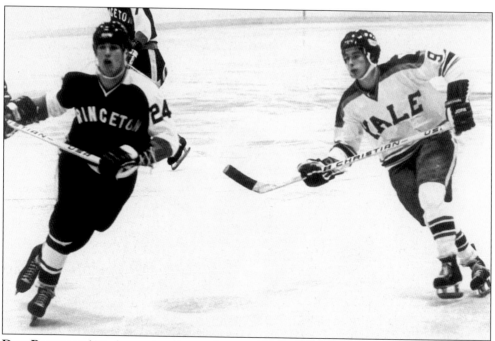

DAN BRUGMAN '81. An outstanding goal scorer, Dan Brugman trailed only the legendary Ding Palmer for career goals when he graduated (his 53 goals is now ninth-best). A standout member of the class of 1981 (which brought Yale its first Ivy League title as seniors), Brugman tied for the team lead in scoring in 1978–79 and tied for the team lead in goals in each of his last three seasons. He took over as one of the team's captains in 1980–81 when the elected captain, Doug Tingey, missed action with a broken arm.

DOUG TINGEY '81. A defenseman from Oakville, Ontario, Doug Tingey captained the 1980–81 Elis, which was the first Yale team to win an Ivy League title (Yale's previous conference championship team was in 1951–52, when it played in the Pentagonal League). Tingey struggled with leg injuries and a broken arm as a senior, playing in only 13 games. He finished his career with 13 goals, 29 assists, and 4 varsity letters. (Photograph by Sabby Frinzi.)

DAN POLIZIANI '82. One of five Yale players to earn Ivy League MVP honors, Dan Poliziani distinguished himself as a high-scoring forward in New Haven and later coached at his alma mater. In 1980–81, he earned team and Ivy honors as he led the Elis to their first Ivy title, posting 17 goals and 21 assists. By the end of his four years, he had surpassed Jack Morrison as the school's all-time leading scorer. He currently stands sixth on the career scoring list with 131 points. After his three-year minor league playing career ended from an eye injury, he followed his mentor, Tim Taylor, into coaching. He served as an assistant coach under Taylor for 10 years and was the interim head coach in 1993–94, while Taylor led the U.S. Olympic team. (Photograph by Sabby Frinzi.)

BILL NICHOLS '83. An outstanding playmaking defenseman, Bill Nichols racked up nine goals and 58 assists, ranking him fifth on the career points list for Yale blue liners. A first-team All-Ivy selection as a senior in 1982–83, Nichols also shared team defensive MVP honors that year with George Minowada. He had his best offensive season as a senior, notching three goals and a career-high 22 assists. He later was an alternate on the 1984 U.S. Olympic team. (Photograph by Sabby Frinzi.)

BILL THURSTON '83. Bill Thurston was a steady and reliable defenseman for four years, including his senior campaign of 1982–83, when he was team captain. Named the team's top defensive player a year earlier, Thurston led the Elis to a 14-14 record, including a 5-0 shutout of Harvard at the New Haven Coliseum. A native of Edmonton, Alberta, Thurston's older brother Gavin played three years of varsity hockey at Yale and graduated in 1981. (Photograph by Sabby Frinzi.)

BOB BROOKE '83. One of the most gifted offensive players in Yale history, Bob Brooke (pictured here playing for Team USA) had a record-setting career in New Haven. He stands as Yale's top player for assists in a career (113) and as a senior, he set the career scoring mark with 155 points (which is now fourth all-time). An All-American in 1982–83, the West Acton, Massachusetts, native was nothing if not consistent. He had 42 points in each of his final three seasons in New Haven. His efforts as a senior made him Yale's first finalist for the Hobey Baker Memorial Award. Selected with the 75th pick of the 1980 NHL Entry Draft by the St. Louis Blues, Brooke went on to a productive seven-year NHL career. He also represented the United States at the Olympics (1984), world championships (1985 and 1987), and Canada Cup (1985 and 1988). He spent the 1983–84 season leading up to the Olympics with Team USA.

MARK CRERAR '83. One of the highest-scoring forwards in Yale history, Crerar finished his career with 111 points. As a junior, he led the Elis in 1981–82, notching 23 goals and 22 assists to earn second-team All-Ivy honors. He was a member of the first team in 1982–83, finishing second on the team in scoring with 34 points. (Photograph by Sabby Frinzi.)

MIKE GILLIGAN. As head coach at the University of Vermont from 1984 until 2003, Mike Gilligan became one of the most successful coaches in NCAA history. He led the Catamounts to three NCAA tournaments and the school's first-ever Frozen Four appearance, in 1995–96. Before he got the Vermont job, he was an assistant coach at Yale under Tim Taylor (1981–82 and 1982–83) and was interim head coach of the 1983–84 Elis as Taylor served as an assistant coach of the 1984 U.S. Olympic team. Under Gilligan, the Bulldogs got off to a 2-9 start but rebounded to finish the season on a 10-4-1 run, ending up with a 12-13-1 record. Although he resigned as hockey coach in May 2003, he continues to coach the golf team at Vermont and is the lead fundraiser for the hockey program. (Photograph by Sabby Frinzi.)

DAVID WILLIAMS '84. As captain in 1983–84, David "Tiger" Williams had to take on more of a leadership role than most team captains, with head coach Tim Taylor assisting Team USA. Without Taylor, the Elis struggled to a 2-9 start before catching fire and finishing the season 10-4-1. A second-team All-Ivy selection in his junior and senior years, Williams had 77 career points. He was also the only member of the freshman class to see regular action on the veteran-laden 1980–81 Ivy champion Elis. (Photograph by Sabby Frinzi.)

PAUL TORTORELLA '84. A 29-game winner in the net for Yale over his career (which ties him for fourth on the school's career wins list), Paul Tortorella had one of his most memorable performances against Harvard—a 5-0 shutout at the New Haven Coliseum in 1983. His best season was his sophomore year, when he was 12-8-1. He was second-team All-Ivy as a senior. He currently teaches English and is the junior varsity hockey coach at Andover, where he was the MVP of the varsity in 1980. (Photograph by Sabby Frinzi.)

PETER SAWKINS '85. A unique story in Yale hockey history, Peter Sawkins was born in Skagen, Denmark, and was a top varsity soccer player. A first-team All-Ivy defenseman on the ice in 1983–84, he was also an All-American sweeper on the pitch in 1984. In fact, he landed in the pages of *Sports Illustrated* for playing in a soccer game against Harvard, followed eight hours later by a hockey game against the U.S. Olympic team. Named the hockey team's top rookie in 1981–82, Sawkins finished his career with 43 points. A 1981 pick of the Los Angeles Kings, Sawkins played three years of minor league hockey, including parts of two seasons with the New Haven Nighthawks of the AHL. (Right, photograph by Diane Sobolewski.)

KEVIN CONLEY '85. The 1984–85 Bulldogs welcomed Tim Taylor back from the Olympics with one of the best years in school history—a 19-11-1 record and Ivy League title with Kevin Conley as captain. The native of Westchester, Massachusetts, had the best offensive season of his career that year with 36 points on 10 goals and 26 assists. He finished with 75 points in his career and was captain when Yale won its 800th game—a 6-2 victory over Harvard. (Photograph by Diane Sobolewski.)

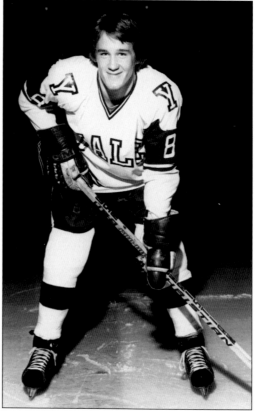

SCOTT WEBSTER '86. One of Yale's defensive stalwarts in the mid-1980s, Scott Webster captained the 1985–86 team, which set what was then a school record with 20 wins and reached the ECAC semifinals. He played in each of Yale's 87 games in his final three years and was the team's defensive co-MVP in 1983–84, along with Paul Marcotte. As a senior, he was named team MVP along with his 12 classmates in the remarkable class of 1986. (Photograph by Sabby Frinzi.)

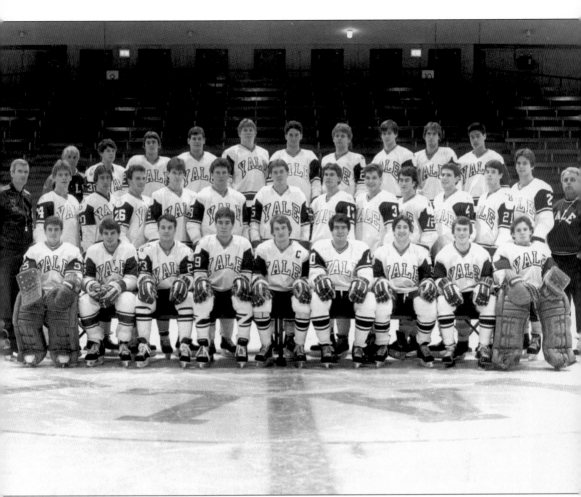

THE 1985–86 TEAM. Starting with a 7-5 win over Harvard to open the season at Ingalls Rink, the 1985–86 Elis re-wrote the Yale record books on their way to a 20-win season and a trip to the ECAC semifinals. Led by an outstanding senior class that included future NHL players Randy Wood and Bob Brooke, the Elis set school records for seasonal goals (160), assists (286), power play goals (59), and power play percentage (34.9). With its 15-6 conference record, the team finished second in the ECAC, a result that has only been surpassed by the 1998 ECAC title team. In the playoffs, the Elis swept St. Lawrence in the quarterfinals at Ingalls Rink before taking on Cornell at the Boston Garden. In an epic and ultimately devastating game, Cornell beat Yale, 3-2 in double-overtime, even though the Elis thoroughly dominated the game (Big Red goaltender Doug Dadswell made 52 saves). (Photograph by Sabby Frinzi.)

RANDY WOOD '86. Randy Wood was an important member of Yale's 1985–86 team, one of the best in school history. A year after exploding for a school-record 53 points as a junior, the right wing from Manchester, Massachusetts, improved on his tally with 55 points and was named second-team All-America. In both seasons, he notched 25 goals—a feat unequaled by any Yale skater over the previous 55 years. His 62 career goals rank sixth in school history, his 79 assists are tied for fifth, and his 141 points are also fifth. Though undrafted, Wood went on to the most successful NHL career of any Yale player, playing 12 seasons, including six years with at least 20 goals (he had 175 goals and 159 assists in 741 career games). He also represented the United States at two world championships and the 1992 Canada Cup. (Photograph by Sabby Frinzi.)

BOB LOGAN '86. An outstanding offensive threat, Bob Logan racked up 122 points in his Yale career, which ranks him seventh in school history. An All-Ivy selection in each of his final three seasons, Logan posted his finest offensive season as a senior with 21 goals—including five game-winners—and 23 assists, helping Yale to 20 wins and the ECAC semifinals. Named the team's top rookie in 1982–83, Logan was twice named team MVP—by himself in 1983–84 and with his 12 classmates in 1985–86. Selected by the Buffalo Sabres in the 1982 NHL draft, Logan played parts of three seasons in the NHL with Buffalo and the L.A. Kings. Logan stayed in the hockey industry after he retired from the game, working for Bauer and then FILA, where he developed several in-line skate patents that became industry standards. (Photograph by Diane Sobolewski.)

BOB KUDELSKI '87. The last in a long line of prolific forwards to play for Yale in the 1980s, Bob Kudelski finished his career as Yale's all-time leading scorer with 158 points and was tops in career goals with 78 (he is now third in both categories and is fourth in career assists with 80). He was the last player cut from the 1988 U.S. Olympic team that included future NHL stars Mike Richter and Brian Leetch. Selected by the Los Angeles Kings with the second overall pick in the 1986 NHL Supplemental Draft, Kudelski played nine years in the NHL for the Kings, Ottawa Senators, and Florida Panthers. A 20-goal scorer for five straight years, including a 40-goal outburst in 1993–94, Kudelski is Yale's only NHL All-Star, playing in the 1994 All-Star game. (Photograph by Sabby Frinzi.)

MICHAEL SCHWALB '87. While most people remember the offensive explosiveness of the 1985–86, some forget that the Elis had a pretty good goaltender who helped Yale to 20 wins that year. Michael Schwalb went 14-6 that year, which ties him for second on the single-season wins list. Schwalb won 29 games at Yale (fourth on the career wins list), and he shared team defensive MVP honors with fellow goaltender Mike O'Neill in 1986–87. (Photograph by Diane Sobolewski.)

ADAM SNOW '87. In four years at Yale, Adam Snow worked his way up from a junior varsity player to a first-line skater. His teammates recognized his hard work, naming him captain of the 1986–87 Bulldogs, who reached the ECAC semifinals for the second consecutive year. Snow has gone on to excel in a different sport—polo. In 2003, he achieved a 10 handicap, the highest possible rating for a polo player, joining only about a dozen other such players from around the world. (Photograph by Diane Sobolewski.)

DAVE TANNER '88. The captain of the 1987–88 Elis, Dave Tanner earned four varsity letters and racked up 81 points on 29 goals and 52 assists. As a senior, he was third on the team with 22 points and notched a hat trick against New Hampshire. He was taken with the 220th pick (11th round) of the 1984 NHL Entry Draft by the Montreal Canadiens, eight rounds after the Habs took an 18-year-old goaltender named Patrick Roy. (Photograph by Sabby Frinzi.)

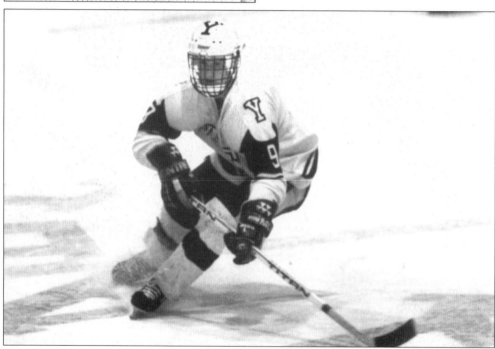

TOM WALSH '89. With 19 goals and 22 assists in 1984–85, Tom Walsh had the finest offensive season of any Yale freshman in history. He missed action for personal reasons and injuries but stayed healthy for all of 1987–88 to earn second-team All-Ivy honors. A broken hand limited him to 16 games in his senior season. His father, Billy, was on Boston College's 1949 national championship team and was a teammate of former Yale head coach Dick Gagliardi. (Photograph by Diane Sobolewski.)

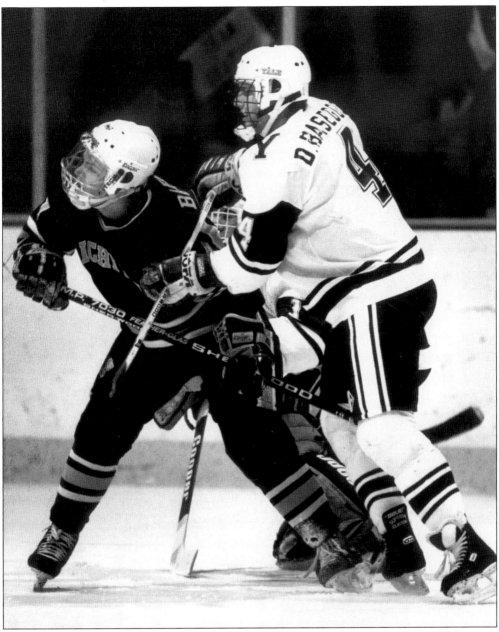

DAVE BASEGGIO '89. The captain of the 1988–89 Elis, Dave Baseggio stands atop Yale's career lists of defenseman goals (29), assists (79), and points (108). The native of Niagara Falls, Ontario, stepped right in as a freshman on a talented and experienced team, playing all 30 games on the blue line as the Elis skated to a 20-10 record. As a senior, he led the Bulldogs with 33 points, including a school-record 10 goals by a defenseman. That year, he was a second-team All-ECAC pick. Selected by the Buffalo Sabres in 1986, Baseggio went on to a 10-year minor league hockey career. He spent the 2001–02 and 2002–03 seasons as an assistant coach with the Bridgeport Sound Tigers of the AHL, coaching former Yale greats Ray Giroux and Jeff Hamilton. His older brother, Rob, also played three varsity seasons for Yale. (Photograph by Diane Sobolewski.)

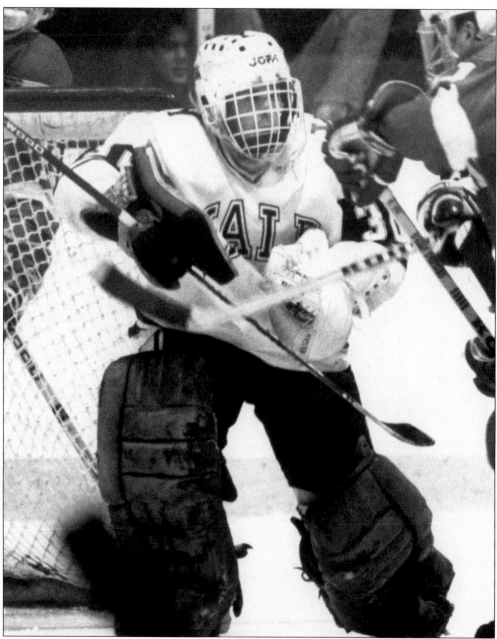

MIKE O'NEILL '89. A first-team All-American, three-time All-ECAC pick, Ivy League MVP, and two-time team MVP, Mike O'Neill racked up an array of accolades throughout his illustrious career between the pipes at Yale. But teammates and fans will always remember him for one particular night—his 47-save performance at Ingalls Rink on January 31, 1989, upsetting Harvard, the undefeated and top-ranked team in the nation (the Crimson went on to win the NCAA title that year). O'Neill, who is fourth on the Yale career saves list with 2,324 stops, was taken by the Winnipeg Jets with the 15th pick in the 1988 NHL Supplemental Draft. He went on to play in the NHL for parts of four seasons, with Winnipeg and Anaheim, and is the only Yale netminder ever to play in the NHL. (Photograph by Diane Sobolewski.)

BILL MATTHEWS '90. In 1986–87, following the loss of 13 seniors from a 20-win team, few people thought the Bulldogs could repeat their performance from the previous year, when they reached the ECAC semifinals. But a freshman class led by defenseman Billy Matthews of Concord, New Hampshire, helped plug some of the holes as the team reached the ECAC semifinals for a second consecutive year. Matthews was named the team's top rookie and later was named the team's best defensive player as a junior. As a senior, he captained the 1989–90 Elis before heading off to Europe after graduation to play a season in the Austrian National League for Kitzbuhel. He returned to the States to attend Wisconsin Law School before embarking on a law and investment banking career. (Photograph by Diane Sobolewski.)

101

CHRIS GRUBER '91. A four-year letterwinner and the captain of the 1990–91 Bulldogs, Chris Gruber was a top defensive forward who was named the team's best defensive player as a junior (with Greg Harrison) and senior. As captain, he helped the Elis to an upset of Brown in the first round of the ECAC tournament before the team bowed out to Clarkson. Gruber finished his career with 19 goals and 35 assists. (Photograph by Diane Sobolewski.)

RAY LETOURNEAU '91. After sitting behind All-American goaltender Mike O'Neill for two years, Letourneau started in the nets as a junior and senior, earning team MVP and honorable mention All-ECAC honors in his final season. He was in goal for all 11 of Yale's wins in 1990–91, including the 2-1 upset win over Brown in the first round of the ECAC playoffs. He stands sixth on the career saves list with 1,858 and played two professional seasons, in the AHL and ECHL.

BRUCE WOLANIN '91. A four-year letterwinner on defense, Bruce Wolanin has returned to Yale for two stints as an assistant coach. After graduation, he played a year of pro hockey before taking a job teaching and coaching at the Pomfret School. He signed back on with the Yale program in 1995–96 and stayed for three years before earning his master's degree in exercise physiology at Connecticut. He returned to the Yale bench in 2000–01 and has been there since, assisting head coach Tim Taylor and associate head coach C.J. Marottolo. (Photograph by Sabby Frinzi.)

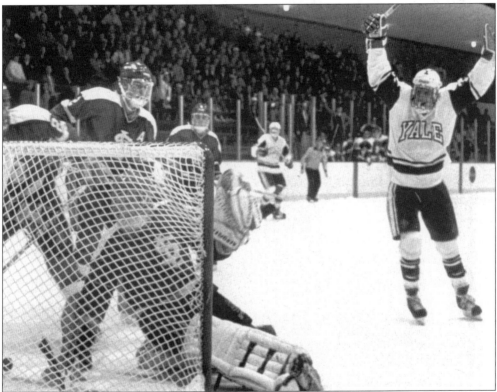

JEFF BLAESER '92. The captain of the 1991–92 Elis, Jeff Blaeser helped lead that team to an Ivy League title. Blaeser made an instant impact as a freshman in 1988–89, earning a spot on the ECAC All-Rookie team as well as team rookie honors. As a sophomore, he led the team with 17 goals and 31 points and was its most valuable player. Though a nagging knee injury slowed him as a senior, he landed a spot in the 100-point club, rounding out his career with 107 points. (Photograph by Sabby Frinzi.)

CRAIG FERGUSON '92. A gritty two-way center, Craig Ferguson was a key contributor on four ECAC playoff teams at Yale. As a freshman, he was a member of the ECAC All-Rookie team. In his junior season, his goal in the first round of the ECAC playoffs lifted Yale to a 2-1 win over Brown. As a senior, he notched a career-high 25 points and was named the team's defensive co-MVP with Peter Allen. He went on to NHL stints with Montreal, Calgary, and Florida. (Photograph by Diane Sobolewski.)

JOHN SATHER '92. An important member of the Yale senior class that helped bring the school its first Ivy League title in seven years, John Sather showed marked offensive improvement from his freshman to his senior seasons. As a freshman, Sather had just six points. But as a junior and senior, he was second on the team in scoring with 34 points and earned second-team All-Ivy honors. He also tied a school record with six assists against St. Lawrence on November 20, 1990. (Photograph by C.W. Pack.)

SCOTT MATUSOVICH '92. A regular on the blue line for four years, Scott Matusovich was an effective player on both ends of the ice. As a senior, he shared team defensive MVP honors with Craig Ferguson while also tying his career high with 16 points (he finished his career with 57 points). That season, he was an All-ECAC and All-Ivy honorable mention. A 1988 draft pick of the Calgary Flames, Matusovich is now the head coach of the hockey team at Yarmouth High School in Maine. (Photograph by Diane Sobolewski.)

PETER ALLEN '93. Peter Allen racked up 18 points in both his junior and senior seasons (mostly assists) while playing rock-solid defense on the Yale blue line. As a senior, he was a second-team All-Ivy, honorable mention All-ECAC, and team defensive co-MVP (with Jack Duffy). A native of Calgary, he has played professional hockey since graduating, including eight games for the Pittsburgh Penguins, in 1995–96. He has also represented Team Canada in tournaments around the globe. In one particularly busy year, he played in 14 different countries. (Photograph by Drew Dole.)

JACK DUFFY '93. A tough, rugged defenseman, Jack Duffy was the first Yale blue liner to earn All-America status. As a senior in 1992–93, Duffy helped the Elis to a 15-12-4 record and was named first-team All-America, All-ECAC, and All-Ivy. A two-time All-ECAC pick, Duffy and classmate Peter Allen formed one of the best defense pairings in the conference. As juniors, they helped the Bulldogs to the 1991–92 Ivy title, Yale's first in seven years. He was also selected by the New York Islanders with the 10th pick in the 1991 NHL Supplemental Draft. After graduation, the Northford native went on to play three professional seasons with the Knoxville Cherokees (ECHL), Las Vegas Thunder (IHL), and Chicago Wolves (IHL). (Photograph by Tomasso DeRosa.)

MARK KAUFMANN '93. Mark Kaufmann was a primary reason that Yale ended a streak of four losing seasons with consecutive winning campaigns in his junior and senior years, including an Ivy League title in 1991–92. Kaufmann led the Elis in scoring in each of his final three seasons in New Haven, improving on his offensive output each year. He never had fewer than 25 points in a season, and notched 25 goals in both 1991–92 and 1992–93, ending his career as Yale's all-time leading scorer with 160 points (he is now second behind Jeff Hamilton). A Hobey Baker Memorial Award finalist in 1992–93, Kaufmann was also a two-time All-ECAC pick and Ivy League MVP in 1992–93. Following his record-breaking career in New Haven, Kaufmann played for the Canadian national team during five different seasons, along with stints in Europe, Japan, and in the AHL.

JAMES LAVISH '93. A consistent scorer for each of his four varsity seasons, James Lavish became a member of the 100-point club as a senior in 1992–93. That year, he had his best offensive campaign, with 17 goals and 19 assists to earn honorable mention All-Ivy honors. The native of Clifton Park, New York, finished his career with 103 points (52 goals and 51 assists) and was a ninth-round pick of the Boston Bruins in the 1989 NHL Entry Draft. (Photograph by C.W. Pack.)

MARTIN LEROUX '94. Martin Leroux experienced the ups and downs of Yale hockey in the early 1990s as much as anyone. In 1992–93, skating alongside eventual career scoring king Mark Kaufmann, Leroux notched 48 points and helped the Elis to a winning season. The following year, with Kaufmann gone to graduation and with head coach Tim Taylor leading the U.S. Olympic team, Leroux was the captain of a team that struggled to a 5-21-1 record. Through it all, Leroux was a steady presence, finishing his career with 115 points (ninth all-time). (Photograph by Rudy Winston.)

TODD SULLIVAN '95. A four-year starter in goal, Todd Sullivan backstopped the Elis to a pair of winning seasons as well as an Ivy title as a freshman, in 1991–92. Over the course of his career, Sullivan broke Keith Allain's record for career saves with 2,365 and was twice named team MVP (in 1993–94 and 1994–95, with Andy Weidenbach). Sullivan stands second on the all-time saves list (behind Alex Westlund), is seventh on the career goals against average list (3.74), and is tied for seventh for career wins (28). A second-team All-Ivy and second-team All-ECAC pick in 1994–95, Sullivan was a product of the Belmont Hill School in Massachusetts, which also sent goaltenders Dan Lombard and Michael Schwalb to Yale. Sullivan went on to play a season in the ECHL before playing overseas. (Photograph by Tomasso DeRosa.)

RICH GIROUX '95. Rich Giroux (left) forms half of a unique pair in Yale history—he and his younger brother, Ray, are the only brothers to act as captains of the Yale hockey team. Rich (below, left) was captain of 1994–95 Elis, who upset nationally ranked Northeastern and Harvard to start the season, and Ray (below, right) was captain of the 1997–98 team. (Left, photograph by Nick Carlino.)

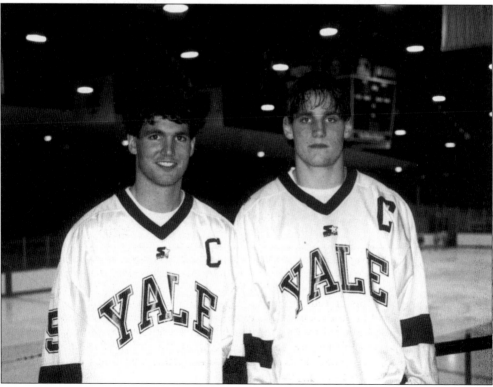

JASON CIPOLLA '95. In his first three years at Yale, Jason Cipolla had a total of 35 points. But as a senior, he exploded for a team-leading 34 points as he picked up honorable mention All-Ivy honors. He also became a hero on campus for preventing a potential assault of a female friend as the two walked towards the woman's apartment. Cipolla was stabbed twice and had to spend two days in the hospital. He made a full recovery and has played professionally since graduation. (Photograph by C.W. Pack.)

ZORAN KOZIC '95. Through the hard work of Tim Taylor and admissions officer Diana Cook, Zoran Kozic escaped his native Belgrade in 1991, just four weeks before the outbreak of full-scale civil war in Yugoslavia. Kozic managed to keep himself out of the draft while Taylor and Cook found a place for him at Yale. He played three varsity seasons and made the most of the opportunity Yale gave him in the classroom, twice earning Academic All-Ivy honors. Having escaped from a home shrouded in war and the failure of communism, Kozic achieved his American dream—playing hockey and receiving an education at an elite American university and using his skills in the capitalist marketplace. Since graduating from Yale, he has gone on to become a partner at Bear Stearns in London.

DAN NYBERG '95. A native of Jarfalla, Sweden, Dan Nyberg was Yale's best defensive player in 1993–94 and 1994–95. As a senior in 1994–95, he had his best offensive season with four goals and 10 assists and was named honorable mention All-Ivy. Over his final three seasons in New Haven, he missed just three games. (Photograph by Steve Conn.)

ANDY WEIDENBACH '95. Andy Weidenbach was the classic coach's son—he did all the little things well, understood the game, and overcame his small stature to become an offensive force in New Haven. Weidenbach wound up his Yale career with 102 points and was a first-team All-Ivy pick, an honorable mention All-ECAC, and a team co-MVP (with Todd Sullivan) in 1994–95. That year, he set the school single-season record with four shorthanded goals, giving him the Yale career record with five. (Photograph by Nick Carlino.)

DAN BRIERLEY '96. At 6-foot-3 and 205 pounds, Dan Brierley was a big, strong defenseman who anchored Yale's blue line corps. A member of the ECAC All-Rookie team and Yale's top rookie in 1992–93, Brierley was a mainstay in the Yale lineup for four years, never missing a game in his career (115 games). As a senior, he had his best offensive campaign with seven goals and 10 assists as he earned second-team All-Ivy honors and was named the team's top defensive player along with Ray Giroux.

JOHN EMMONS '96. Twice a member of the U.S. junior national team, and its captain in 1994, John Emmons has played on the national, international, and professional levels during his career. A first-team All-Ivy selection and team MVP in his senior year, Emmons led the team with 28 points in 1995–96. An honorable mention All-Ivy pick as a junior and Yale's all-time penalty minutes king, Emmons played parts of three seasons in the NHL with Ottawa, Tampa Bay, and Boston.

PRESCOTT LOGAN '96. A native of Wayzata, Minnesota, Prescott Logan was captain of the 1995–96 Bulldogs, who posted a thrilling 6-5 win over Harvard at Ingalls Rink. Logan scored a pair of goals as a senior, one of his two varsity seasons. After Yale, Logan earned his Master of Business Administration from the Kellogg School of Management. (Photograph by C.W. Pack.)

JOSH RABJOHNS '97. Yale's captain in 1996–97, Josh Rabjohns helped bring the Bulldogs back to the ECAC tournament after three straight absences. Not only did the Elis get into the postseason, but they also pulled off an enormous upset, knocking off Colgate, 1-0, in the opening round game. The forward from Northbrook, Illinois, was named the team's top rookie in 1993–94.

114

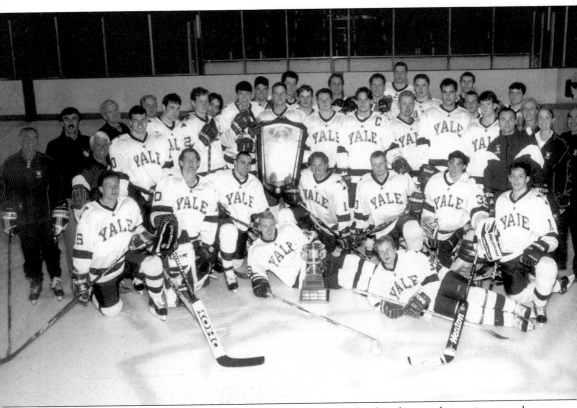

THE 1997–98 TEAM. The most storybook season in Yale hockey history began innocently enough, with a 5-1 win over Air Force at Ingalls Rink. By the end of the year, the Bulldogs had done the unfathomable; picked to finish 10th in the ECAC, they won 23 games, claimed the regular season ECAC title, triumphed at Harvard's Bright Center for the first time in 20 tries, performed miracles on two consecutive nights in the ECAC quarterfinals (courtesy of goals by Ray Giroux, John Chyz, and Jay Quenville), and earned a trip to Lake Placid and the ECAC semifinals. Three All-Americans—defenseman and captain Giroux, center Jeff Hamilton, and goaltender Alex Westlund—and a host of unsung players gave Yale its finest season ever and its first berth in the NCAA tournament since 1952. With injuries to several key players (Hamilton included), the story ended in the first round of the NCAA tournament with a loss to Ohio State.

RAY GIROUX '98. Ray Giroux was possibly the best defenseman ever to wear Yale blue and white. He was certainly the most decorated—he is Yale's only ECAC Player of the Year, was a Hobey Baker Memorial Award finalist, and was named to the ECAC's All-Decade team for the 1990s. Accolades aside, Giroux will best be remembered as the captain of the 1997–98 Yale team that was picked to finish 10th in the conference and ended up winning the regular season title. Since graduating, Giroux has played for the New York Islanders and New Jersey Devils in the NHL. He has also been an AHL All-Star and was named "Man of the Year" by the Albany River Rats of the AHL in 2002–03. His brother, Rich, was the captain of the 1994–95 Yale team. (Photograph by Steve Conn.)

116

DARYL JONES '98. While Ray Giroux garnered many of the headlines from the Yale blue line in 1997–98, his defense partner, Daryl Jones, was performing his share of the dirty work. A tough defensive player who became an important offensive contributor, Jones, with 47 points, ranks 10th on the Yale career scoring list for defensemen. He was an honorable mention All-ECAC and second-team All-Ivy selection in 1997–98 in addition to being an important senior leader on that year's ECAC championship team. (Photograph by Don Clark.)

MATT CUMMING '98. Yale fans in Houston Field House on March 7, 1998, will always remember Matt Cumming's goal in the waning moments of the 1997–98 season finale. His empty-netter against Rensselaer was not the season's most important goal, but it allowed the Yale players, coaches, and fans to finally exhale after a tense run to the ECAC regular season crown. Cumming was a consistent offensive presence during his career, notching nine goals and 22 assists as a senior to earn honorable mention All-ECAC honors. (Photograph by C.W. Pack.)

117

ALEX WESTLUND '99. Alex Westlund was as responsible as anyone for Yale's move to the top of the ECAC in the late 1990s. The school's only winner of the Dryden Award, given to the ECAC's top goaltender, Westlund set Yale career records for wins (42), saves (2,704), and save percentage (.902) and posted the best career goals against average of an Eli netminder in 64 years. His 46-save performance in an opening-round upset of Colgate in the 1997 ECAC tournament was the turning point for the Yale program and was a glimpse of some of Westlund's spectacular play the following two seasons. After graduation, he played three seasons of minor league hockey before heading off to play the 2002–03 campaign in Russia, prompting one publication to term him the "most traveled goalie in the world." (Photograph by C.W. Pack.)

KEITH MCCULLOUGH '99. As intense a leader as Yale has ever had, Keith McCullough was captain of the 1998–99 Ivy League champion Elis. After his pregame preparation, when he would put himself into a focused, almost trance-like state, the center would unleash his fury on the other team's top scorer, playing relentless defense and repeatedly winning face-offs. He also led the team with 24 points as a sophomore in 1996–97. Under his leadership, the 1998–99 Elis went 8-2-3 to end the regular season, clinching their second consecutive Ivy title.

JEFF BROW '00. For four years, Jeff Brow was a consistent offensive producer. He finished in the top five on the team in scoring in each of his four seasons and was second on the team twice. As a junior, Brow finished the year with 16 goals and 22 assists, both career-highs, as he was named second-team All-Ivy. He finished his career with 113 points and played in 118 games, which places him fourth in school history. (Photograph by Don Clark.)

CORY SHEA '00. One of the toughest players in Yale history, Cory Shea battled injuries throughout his career but still threw himself all over the ice with little regard for his body—or those of his opponents. The captain of the 1999–2000 Bulldogs, Shea was an outstanding defensive center who excelled on the penalty kill and was adept at knocking in shorthanded goals. He also scored one of the magical goals of the 1997–98 season, an overtime marker to win at Cornell. (Photograph by Steve Conn.)

TREVOR HANGER '00. Sharing time with Dan Lombard in 1999–2000, Trevor Hanger of nearby Guilford posted a .906 save percentage and had the ninth-best single-season GAA in school history (2.80). His play that season earned him honorable mention All-Ivy honors. His most memorable performance came on the road against Boston University in 2000, when he made a series of brilliant stops to preserve a 1-1 tie with the sixth-ranked Terriers. (Photograph by Steve Conn.)

JEFF HAMILTON '01. The leading scorer in school history with 173 points, Jeff Hamilton was both a brilliant goal-scorer and an exquisite passer. The only two-time Hobey Baker Memorial Award finalist in school history, he was also a three-time All-American and twice the Ivy League Player of the Year. Hamilton established himself as one of the country's most gifted offensive players as a sophomore in 1997–98, helping the Bulldogs to their first ECAC title in school history and a bid to the NCAA tournament. After leading the ECAC in conference scoring as a junior, Hamilton sat out the 1999–2000 season with an abdominal injury, returning for his final year in 2000–01. That season, he led the Elis to their third Ivy title in four years and broke Mark Kaufmann's scoring record. He spent the 2002–03 season with the Bridgeport Sound Tigers, the AHL affiliate of the New York Islanders.

BEN STAFFORD '01. Ben Stafford was an integral part of an ECAC title team and three Ivy League champions. As a junior, he led the team in scoring, earning team MVP honors along with first-team All-Ivy and honorable mention All-ECAC status. As a senior, he captained the Bulldogs to an Ivy League title and posted the best offensive season of his career—14 goals and 32 assists—rounding out his career with 110 points. He was named "Man of the Year" by the Philadelphia Phantoms of the AHL in 2003.

LUKE EARL '02. A tough, gritty forward, Luke Earl captained the 2001–02 Elis and was the team's second-leading scorer that year with 23 points. After two years as a defensive-minded player, he emerged as a scoring threat towards the end of the 2000–01 season while playing on a line with Jeff Hamilton. Earlier that year, he scored one of his most memorable goals at New Hampshire—a shorthanded breakaway effort that gave the Elis a 4-3 win. He was a second-team All-Ivy pick in 2001–02.

DAN LOMBARD '02. Dan Lombard followed in the tradition of previous Belmont Hill School goaltenders Michael Schwalb and Todd Sullivan to play at Yale. Lombard shared the starting role with Trevor Hanger for a season before taking on the starting job himself for two years. He posted some of the best numbers in Yale history, finishing second in school history for career GAA (3.09) and fifth in career saves (1,986). As a senior, he was the team's most valuable player. (Photograph by Don Clark.)

NICK DESCHENES '03. At 6-foot-3, 220 pounds, with solid offensive skills, Nick Deschenes was a powerful offensive force in front of opposing nets for four years. A second-team All-Ivy pick in 2000–01 as a sophomore, Deschenes was second on the team that season with 37 points, including eight power-play goals. He scored in his first career game, giving Yale a 1-0 lead at defending NCAA champion Michigan (the Wolverines eventually won, 3-2). He signed with the Philadelphia Flyers after his senior season. (Photograph by John Powers.)

DENIS NAM '03. One of the fastest skaters in recent Yale history, Denis Nam developed into a solid two-way forward by his senior year. A native of Northfield, Illinois, Nam played his prep hockey at Taft and captained the 2002–03 Elis to a fourth-place finish in the ECAC. He ended his career with 13 goals and 18 assists in 95 games. He plans to attend medical school. (Photograph by C.W. Pack.)

BRYAN FREEMAN '03. Bryan Freeman led one of the most unique careers in college hockey history. On his first career shift as a freshman, Freeman scored a goal. By the end of that 5-2 win over Vermont, the rookie defenseman had notched a hat trick, becoming the first Yale freshman to achieve the feat. He went on to become a defensive mainstay for the rest of his career with 105 more appearances in the Yale lineup, but he never scored another goal.

Jeff Dwyer '04. Jeff Dwyer came to Yale as the school's first NHL draft pick (Atlanta) since Ray Giroux in 1994. In his first three seasons, he proved to be one of the most prolific offensive defensemen in school history, racking up 53 points on 10 goals and 43 assists. He enters the 2003–04 campaign eighth on the Yale career scoring list for defensemen. Dwyer was the Ivy League co-Rookie of the Year in 2000–01 and was named to the ECAC All-Rookie team.

Vin Hellemeyer '04. A scrappy offensive presence, Vin Hellemeyer has improved on his points total every year since coming to New Haven. As a freshman, he had three points, 20 as a sophomore, and 31 as a junior (11 goals and 20 assists). Following his junior campaign, he was elected captain of the 2003–04 Bulldogs. Hellemeyer came to Yale from Franklin Square, New York, and played for the U.S. Select-17 team that traveled to the Czech Republic in August 1999. (Photograph by John Powers.)

CHRIS HIGGINS '05. One of the brightest stars to suit up for Yale was Chris Higgins, who played just two seasons in New Haven before signing with the Montreal Canadiens in May 2003. In his freshman season, he led the Elis in scoring with 31 points, earning him ECAC and Ivy League Rookie of the Year honors—despite missing four games to play in the world junior championships, where he was Team USA's leading scorer. After his freshman year, the Montreal Canadiens made him the 14th overall selection in the NHL Entry Draft—Yale's only first-round NHL draft pick. As a sophomore, he was first-team All-America, a finalist for the Hobey Baker Memorial Award, and the ECAC co-MVP, racking up a team-leading 41 points, though he again missed time to represent the United States at the world junior championships.

THE NEW HAVEN ARENA. From the team's inception until 1927, Yale played on a variety of outdoor and indoor rinks. But it was not until the opening of the "new" New Haven Arena, in 1927, that Yale truly had a home. Built on the corners of Orange, Wall, and State Streets, the arena held a capacity of approximately 3,700 fans and replaced the previous rink, which had burned down in June 1924. The arena was the home of Yale hockey until 1959.

INGALLS RINK. The Bulldogs' current home, David S. Ingalls Rink opened to Yale hockey in 1959 and is known throughout the hockey world as the "Yale Whale" for its humpbacked structure. The rink is named for two captains of Yale hockey teams—David S. Ingalls Sr., class of 1920, and David S. Ingalls Jr., class of 1956. The Ingalls family gave much of the money for the building, which was designed by noted Finnish-born architect Eero Saarinen. A 1934 graduate of Yale, Saarinen wrote, "What intrigues me most is to imagine archeologists 5,000 years from now digging in New Haven and first coming across prehistoric bones in the Peabody Museum and then not so far away from there finding this huge dinosaur-like skeleton. What kind of history will they reconstruct about what formidable creatures Yale men were in the mid-20th century?" These photographs show what Ingalls Rink looked like during construction and what it looks like on the inside.